COLOR MANUAL

STEPHEN J. SIDELINGER
Kansas City Art Institute

PRENTICE-HALL, INC., Englewood Cliffs, N.J. 07632

Library of Congress Cataloging in Publication Data

Sidelinger, Stephen J., 1947–
 Color manual.

 Bibliography: p. 119
 1. Color in art. 2. Colors. I. Title.
ND1488.S53 1985 701'.8 84-26331
ISBN 0-13-152041-5

to my parents, teachers, and friends

Editorial/production supervision: Virginia Rubens
Interior design: Janet Schmid
Cover design: Dawn Stanley
Manufacturing buyer: Ray Keating
Page layout: William Schwartz

Printed in the United States of America

10 9 8 7 6 5 4 3 2 1

0-13-152041-5 01

Prentice-Hall International, Inc., *London*
Prentice-Hall of Australia Pty. Limited, *Sydney*
Editora Prentice-Hall do Brasil, Ltda., *Rio de Janeiro*
Prentice-Hall Canada Inc., *Toronto*
Prentice-Hall Hispanoamericana, S.A., *Mexico*
Prentice-Hall of India Private Limited, *New Delhi*
Prentice-Hall of Japan, Inc., *Tokyo*
Prentice-Hall of Southeast Asia Pte. Ltd., *Singapore*
Whitehall Books Limited, *Wellington, New Zealand*

CONTENTS

PREFACE

A manual is a small handbook designed to give useful instructions and to serve as a reference.

The objectives of this manual are:

- to give a compilation of the basic information about color,
- to give a usable explanation of each color concept,
- and to give a visual illustration of the color concepts in a diagram and/or a piece of art or design, with exercises to accompany each concept.

The manual is also designed to be used as a reference for the review of specific color concepts when needed.

1

COLOR THINKING

There are three conceptual problems to be overcome when someone starts to think in color.

The **first problem** is that all concepts about color are theoretical, and there are sometimes different versions of a concept. Therefore no color concept can be stated as proven fact. These inconsistencies often perplex someone who starts to think in color.

The **second problem** is that practical color methods have been well established for a long time and are relatively consistent. The practical concepts are obviously related to the theoretical concepts, but exactly how is still not proven. The contradiction between practical color concepts and theoretical color concepts can cause some confusion when someone starts to think in color.

The **third problem** is that color still seems somewhat mystical. Ancient cultures thought of color as symbolically divine, and some of that mystical sense remains today. The sense of mysticism can cause some anxiety. Someone who starts to think in color may feel color is a sacred domain which should not be violated.

Color thinking is theoretical, practical, and mystical at the same time.

There are **two types of color mentalities**. One type of mentality seems to have a natural and intuitive understanding of color. The other mentality has to study the effects of color until the knowledge feels secure. When the knowledge of color is used repeatedly, color thinking becomes more natural and instinctive.

Color is like a language; once the grammar is learned, the language can be used spontaneously. In coloration, once the color effects are understood the effects can be used easily and naturally.

The artist Wassily Kandinsky advises someone who starts to think in color to study the color effects, use the color effects simply and directly, and start to consider the psychological associations with color.

When someone starts to work with color, an important point is to begin to notice colors and try to start thinking in colors rather than just in black and white.

PROBLEM 1

A good exercise for someone to start to think in color is to **collect** all kinds of solid-colored papers which appeal to you, such as art paper, writing paper, wrapping paper, paper bags, and book endpapers. **Trim** all the papers into neat flat sheets, and remove any typography or solid areas. **Store** the collection in a large flat envelope or box. The collection should consist of at least two hundred pieces of solid-colored paper. The pieces of colored paper may be any size, weight, or texture. The colored paper collection will be essential in many of the other color problems in the manual.

PROBLEM 2

A helpful exercise when someone starts to think in color is to collect colored photographs from magazines. **Try to select** photographs for the color appeal rather than for the subject matter. Neatly trim all the photographs and store the collection in a flat envelope or box. The collection should consist of at least fifty photographs. The collection will be useful in several of the other color problems in the manual.

Display some of the collection so the photographs can be seen often, and change the images periodically. The display should heighten the awareness of colors and the effects of colors.

2

PHYSIOLOGY OF THE EYE

The human eye is a fairly complex and delicate organ. Study of the eye to find out exactly how color vision functions is difficult. Therefore, there are only theories about the color vision structures of the eye.

The retinal walls of the eye are known to contain light sensors called rods and cones. The rods of the eye are said to be sensitive to light and dark. The cones are said to be sensitive to the different wavelengths of colored light.

The cones are very dense in the back center of the retinal walls and are said to be highly sensitive to yellow. Out from the center of the retinal walls, the rods gradually intermix with the cones. The number of cones decreases as the number of rods increases, until the rods reach full density at the front edges of the retinal walls. Color sensitivity is, therefore, said to be greater in the center of the retinal walls, while dark and light sensitivity is said to be greater on the edges of the retinal walls.

The rods and cones are assumed to transmit color messages via the surfaces of the retinal walls to the optic nerve and then to the brain.

The most widely accepted theory of the function of the color sensors of the eye is the **Young-Helmholtz theory,** proposed by Young in 1807. The Young-Helmholtz theory assumes that the cones are subdivided into three types of color sensors which correspond to the three primary hues of white light. One set of sensors is stimulated when red is seen, one set when green is seen, and one set when blue is seen. Originally blue was referred to as violet.

When the red and blue sensors are stimulated together, the color magenta is seen. When the blue and green function together, cyan or turquoise is seen. The green and red sensors respond together to see yellow. All other colors are seen by varying amounts of stimulation of the three sensors.

When all three of the color sensors are stimulated together, in equal intensity, white is seen. When there is no stimulation of the sensors, black is seen.

There are several other theories of how the primary color sensors function. However, the Young-Helmholtz psychophysiological color theory is the basis for most of the practical color effects discussed in the manual.

The use of a theoretical constant assures that the color effects will always operate in the same manner.

THEORIES OF COLOR VISION	
Theory	*Primaries*
Young	red
	green
	violet
Helmholtz	red
	green
	violet
Ladd-Franklin	red
	green
	blue
Hering	red-green
	yellow-blue
	white-black
Adams	red
	green
	blue
Muller	yellowRED-blueGREEN
	greenYELLOW-redBLUE
	Luminosity
E. H. Land	Contrast

3 THE THREE ATTRIBUTES OF COLOR

Albert H. Munsell was a seascape painter in the 1890s. Munsell set out to organize coloration so the colors could be more accurately discussed. Munsell wanted to replace the inconsistencies of trade names, scientific terms, and artists' vocabulary with a more concise system of color names. Munsell wanted to overcome the problem of inexact color terminology—the problem that what one person calls "magenta," for example, may not be what another person calls magenta.

In 1905 Munsell published a system of color names known as the **Munsell System of Color Notation**. The Munsell System was so well constructed that the system is still used today by many institutions where coloration is critical. The Munsell System of Color Notation serves as one of the color references of the United States National Bureau of Standards.

The Munsell System is quite large in scope, but very simple to understand and use.

The Munsell System is a set of charts arranged three-dimensionally in a configuration known as the Munsell Color Tree. Each of the color chips, on each of the charts, is an individual color. The spaces not filled on the charts were left by Munsell for new colors to be added as colors were discovered.

FIGURE 1
page 93

The **first attribute** or dimension of a color is **hue**.

Hue is the name of the pure state of a color or chromatic group, determined by wavelengths which distinguish one color from another.

There are one hundred different hues in the Munsell System. Each hue is a chart/leaf on the color tree. These charts are arranged in a circle around the neutral gray pole, or trunk, in the center of the tree.

In the Munsell System there are five **principal hues**:

Red
Yellow
Green
Blue
Purple

FIGURE 2
page 93

All of the principal hues are coded with the number 5.0. For example, the code on the top of the chart for the principal hue Red is 5.0 R, the code for the principal hue Yellow is 5.0 Y, and so on for the other principal hues—5.0 G, 5.0 B, and 5.0 P.

In the Munsell System there are five **intermediate hues**:

Yellow-Red
Green-Yellow
Blue-Green
Purple-Blue
Red-Purple

FIGURE 3
page 93

The intermediate hues are also coded with the number 5.0 but have double letters. For example, Yellow-Red is coded 5.0 YR, Green-Yellow is coded 5.0 GY, and so on for the other intermediate hues—5.0 BG, 5.0 PB, and 5.0 RP.

The Munsell System has ten **secondary hues**:

Red-Yellow-Red
Yellow-Red-Yellow
Yellow-Green-Yellow
Green-Yellow-Green
Green-Blue-Green
Blue-Blue-Green
Blue-Purple-Blue
Purple-Purple-Blue
Purple-Red-Purple
Red-Purple-Red

FIGURE 4
page 93

The secondary hues are coded on the color charts with the number 10.0 and three letters. Red-Yellow-Red is coded 10.0 RYR, Yellow-Red-Yellow is coded 10.0 YRY, and so on for the other secondary hues.

Finally, there are eighty special intermediate hues, coded from 1.0 to 4.0 and 6.0 to 9.0, between each of the principal or intermediate hues and each of the secondary hues. These special hue charts are not shown on the tree since the special intermediate hues are seldom used except for

very specific purposes. The special intermediate hues, however, complete the scope of the Munsell System.

For most purposes, only the five principal hues, the five intermediate hues, and the ten secondary hues are necessary.

FIGURE 5
page 94

The **second attribute** or dimension of a color is **value**.

Value is the lightness or darkness of a hue.

The term value replaces such terms as brightness, luminosity, reflection, and the misused terms tints and shades. Munsell used the term value instead, since there are shades of yellow which are actually lighter than some tints of blue.

In the Munsell System the values of each hue are determined individually by comparison with the common neutral gray center pole. Values are arranged up and down on each hue chart/leaf of the color tree in relation to the neutral pole.

There are nine value levels in the Munsell System. The seven gray value levels of the neutral pole are coded N_2 to N_8. The N stands for neutral, and the value-level code number is written above the slash line.

FIGURE 6
page 94

Pure black would be coded N_1 and pure white N_9. In the Munsell System, pure black and white were thought of as impossible ideals to achieve and were not included.

The value position of each chip on each hue chart/leaf is determined by the comparison of the color chip to the gray scale of the neutral pole and the placement of the chip to the right of the pole at the value level.

FIGURE 7
page 94

The value of a hue is shown in the Munsell color notation code above the slash line and after the hue letter. For example, a light valued red, commonly called pink, would be coded 5.0 R_7.

The **third attribute** or dimension of a color is **chroma**.

Chroma may be a new term and one which can cause some confusion. The concept of chroma is very simple. Chroma is the amount of weakness or strength of a hue at a certain value. The term chroma replaces such terms as purity, saturation, intensity, and colorfulness.

For example, two red apples may have the same value—lightness or darkness—but one apple may be much redder than the other. The redder apple has more intense chroma. The redder apple is not darker, the apple is merely redder.

For another example of chroma, take a small amount of medium gray, N_5

paint and add two drops of red paint. The gray will not get lighter but will get slightly redder. Add two more drops, or a total of four drops, and the gray will be redder yet. If two drops at a time are added to the mixture, the gray will continue to get more intensely red, until at sixteen drops the gray is turned almost pure red. If two more drops are added, or eighteen drops, the color gets not only purer, but lighter, so the red is then at a higher value, not a more intense chroma.

The attribute of chroma is arranged outwardly from the neutral gray pole, each at a given value on each hue chart/leaf. There are fourteen possible steps of intensity of chroma on each value level.

The chroma step in a Munsell color notation is written below the slash line under the value number. For example, 5.0 R$7/10$ is the notation for a light intense red.

There are thirty color chips on the 5.0 R chart. Each hue chart has a different number of chips, depending on the chroma possibilities of each hue at the seven value levels.

To communicate a color with the Munsell System of Color Notation, the code must show all three attributes—the hue, 5.0 R, the value level, 5.0 R$7/$, and the chroma step, 5.0 R$7/10$.

A Munsell color notation leaves no room for error or doubt. The exact color chip is known, and the color chip can also be seen in relation to the whole system.

There are three ways to use the Munsell System to solve color problems, as discussed in Chapter 10, Proportions of Hues; Chapter 12, Color Combinations; and Chapter 13, Color Schemes.

PROBLEM 3

The way to fully understand a color system like the Munsell System is to use the system. A good way to use a system is to code your collection of colored papers from Problem 1. **Use** the color charts provided in the Color Index, and **try to determine** the hue, value, and chroma of the pieces of your colored paper collection.

Set each piece of colored paper on the chart, and move the paper slowly over the chart until the proper position is determined. Write the code of the colored paper on the back of the paper.

Some of the colors will fall in between the chips of a color system. In these cases, code the paper with the best possible position in the system.

4

PRIMARY HUES

A primary hue is one color of a color system which cannot be made from the other colors in the system. Primary hues are the base hues for mixing all the other colors of a system.

A secondary hue is a color which can be created when any two primary hues of a color system are mixed.

There are **two systems of primary and secondary hues**.

One system of primary hues is the **additive system of primary hues**. The additive system of primary hues deals with light, either white or colored light, as the light is seen, projected, or reflected.

FIGURE 8
page 95

The additive primary hues, sometimes called the eye primaries, are directly related to the Young-Helmholtz theory of color vision.

In the additive system of primary hues are:

Red
Green
Blue

The additive primary hues, when equal in intensity, combine together to make the lighter additive secondary hues:

Red and Blue make Magenta
Blue and Green make Cyan
Green and Red make Yellow

In theory, all three additive primary hues combine together to make white.

Though the additive system of primary hues is important to the understanding of all theories of color vision, the additive system is most often used practically in colored lighting.

The additive system of primary hues is the basis for color television, colored lights for the stage, fountains, parks, gardens, buildings, exhibitions, and lasers.

In **color television** the beams of three electron guns of red, green, and blue are directed through a mesh of dots or stripes to three corresponding red, green, and blue phosphorous dots arranged in a continuous pattern of triangles directly on the inside back of the screen. Full-color television images are the result of optical mixtures in the eye, as discussed in Chapter 7, Afterimage and the Simultaneous Contrast of Hues.

The other system of primary hues is the **subtractive system of primary hues.** The subtractive system of hues deals mainly with pigments and dyes or colors which absorb light. There are two versions of the subtractive system of primary hues.

In one version of the subtractive system of primary hues, developed by the Prang Company in 1914, the primary hues are

Red
Yellow
Blue

These primary hues mix together to make the darker secondary hues:

Red and Blue make Purple
Blue and Yellow make Green
Yellow and Red make Orange

In theory all three subtractive primary hues mix together to make black; in practice the mixed color is not a pure black.

The other version of the subtractive system of primary hues is only an updated version of the red, yellow, and blue subtractive system of primary hues. The newer version is the result of new developments in chemical colors and processes.

In the newer version of the subtractive system of primary hues the primary hues are:

Magenta
Yellow
Cyan

These primary hues mix together to make the darker subtractive secondary hues:

Magenta and Cyan make Blue
Cyan and Yellow make Green
Yellow and Magenta make Red

In theory all three of these primary hues mix together to make black. These primary hues actually can be mixed together to make a very dark blue-purple, called process black.

The newer version of the subtractive system of primary hues is the inversion of the additive system of primary hues.

Color printing processes and color photography are based on the newer version of the subtractive system of primary hues.

In the **three-color printing process,** screens of tiny dots of magenta, sometimes called process red or just red; cyan, sometimes called process blue or blue; and yellow are printed in thin layers on top of one another. The screens are shifted slightly so the dots do not overlap completely. When printed, the process yields an image in full color and black, with white being derived from the color of the paper.

The simplest of the color effects is based on the contrast of at least three pure subtractive primary hues or three secondary hues. The most extreme contrast is of the primary hues red, yellow, and blue, or magenta, yellow, and cyan.

The strength of the contrast effect of primary hues is equal to the contrast of black and white.

The contrast of hues diminishes the farther removed the hues are from the primary hues. The contrast of secondary hues purple, green, and orange or blue, green, and red is strong, but not as strong as the contrast of primary hues.

FIGURE 9
page 95

The effect of the contrast of hues is always vigorous and decided. The undiluted primary and secondary hues have a primitive and direct quality.

The contrast of hues can be varied by the introduction of black, white, and gray.

FIGURE 10
page 95

When **black surrounds** or separates the hues, the effect of the contrast is increased, the individual character of the hues is sharper, and the hues have less influence on one another.

FIGURES 11, 13
pages 95, 96

When **white surrounds** or separates the hues, the effect of the contrast is decreased, the individual character of the hues is weaker, and the hues have less influence on each other.

FIGURES 12, 14
pages 95, 96

When **gray or brown is intermixed** with the hues, the effect of the contrast can be neutralized and/or enriched.

The effect of the contrast of hues can also be varied by the **regulation of the proportions** of each hue.

When the hues are used in equal proportions, the effect of the contrast is neutralized.

When the hues are used in unequal proportions, the effect of the contrast is increased.

PROBLEM 4

To actually see the additive system of primary hues is helpful in enabling you to remember the hues of the system and how the system functions.

A simple way to produce the additive system of primary hues is to **fill** three clear eight-ounce glass jars with water. Then **put** about ten drops of red food color in one jar, ten drops of blue food color in another jar, and ten drops of green food color in the last jar. Try to balance the intensity of the hues in the three jars.

In a darkened room, place the three jars side by side, and **shine a flashlight** through each jar. Where the flashlight beams overlap, you should be able to make out the additive primary and secondary hues and the white intermixture of all three primary hues.

PROBLEM 5

The physical production of the subtractive system of primary hues is also important, to see how the system functions in practice.

Use any liquid color agent (gouache paint is recommended) and mix a moderate amount of subtractive primary hues red, yellow, and blue. **Intermix** these primary hues to form the subtractive secondary hues. Also **intermix** all three primary hues together to see what black results. These intermixtures are not mathematically predictable, and it may take some practice to adjust the proportions of the mixtures.

Apply each of the primary hues and the secondary hues mixed to the full surface of the blank side of a three-by-five-inch index card. **Paint** each of the mixed colors on two separate cards.

Complete the same process with the other version of the subtractive system of primary hues of magenta, yellow, and cyan.

Compare the intermixtures of the two versions of the subtractive system of primary hues.

Intermix different values of neutral gray with each set of the subtractive primary hues, and apply each of the mixtures to two index cards.

Four-inch board with grid

PROBLEM 6

Cut all of the painted three-by-five-inch index cards from Problem 5 into fifteen one-inch squares. Keep the squares of each color in a separate pile.

Cut out ten four-by-four-inch smooth-surfaced mat boards which are white on one side and black on the other.

Lightly pencil a one-inch square grid on the white side of nine boards and the black side of one board.

On **one white board** arrange only the red, blue and yellow squares in a design which completely fills the grid. The design should be based on the extreme contrast effects of the primary hues.

On the **second white** board completely fill the grid with a design of only magenta, yellow, and cyan squares based on the extreme contrast effects of the primary hues.

On the **third white** board completely fill the grid with a design of only purple, green, and orange squares based on the effects of contrast of the secondary hues.

On the **fourth white** board completely fill the grid with a design of only blue, green, and red squares based on the effects of contrast of the secondary hues.

On the **fifth white** board arrange only six squares, two of red, two of yellow, and two of blue, so a dominant proportion of white is left visible in the design. Base the design on the effects of the primary hues surrounded by white.

On the **sixth board,** use the grid on the black side of the board, and arrange only six squares, two of magenta, two of yellow, and two of cyan, so a dominant proportion of the black is left visible in the design. Base the design on the effects of the primary hues surrounded by black.

On the **seventh white** board completely fill the grid with only squares of the primary hues which have been intermixed with gray. Base the design on the effects of primary hues intermixed with gray.

On the **eighth white** board completely fill the grid with only red, yellow, and blue squares; design the grid based on the effects of the primary hues in equally proportioned areas.

On the **ninth white** board completely fill the grid with only magenta, yellow, and cyan squares; design the grid based on the effects of the primary hues in unequally proportioned areas.

On the **tenth white** board completely fill the grid with any and all leftover squares, and experiment with the proportions and the interaction of the hues used in the design.

Lightly glue all the finished designs in place.

Display the finished boards so the exercise can be seen often, and **review** the results in relation to each of the color effects of the primary hues discussed in this chapter of the manual.

5

OPPOSITE HUES

Every color has a complementary color. Munsell used the more appropriate term *opposite hue,* since these pairs of hues sit directly opposite each other on a color circle and do not necessarily have a complementary effect on each other.

The opposite hues may differ slightly, depending on the color circle which is used.

The most **commonly used subtractive opposite hues** are:

Red and Green
Yellow and Purple
Blue and Orange
Red-Purple and Yellow-Green
Yellow-Orange and Blue-Purple
Blue-Green and Red-Orange

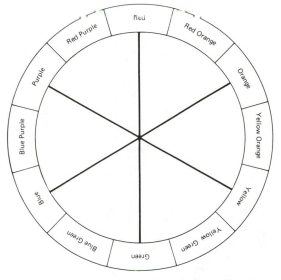

Subtractive Opposite Hues (Manual Color Circle)

FIGURE 18
page 97

Any set of opposite hues, equal in value and chroma, will theoretically intermix to form a neutral gray or a gray which tends toward no definite color. **Neutral gray** is also commonly called **complementary gray**. A complementary gray is different in appearance from a gray mixed from black and white. A complementary gray is warmer in appearance, more intense in effect, and more harmonious with other hues. In practice, the mixed gray is not always a true gray.

FIGURE 19
page 97

The second most commonly used sets of opposite hues are the **Munsell opposites**. These sets of subtractive opposite hues are derived from the additive system of primary hues and the theory of afterimage discussed in Chapter 7, Afterimage and the Simultaneous Contrast of Hues.

The second group of opposite hues are:

FIGURE 20
page 97

Red and Blue-Green
Yellow and Purple-Blue
Blue and Yellow-Red
Green and Red-Purple
Purple and Green-Yellow

The Munsell opposite hues also theoretically intermix to a neutral gray.

FIGURE 21
page 97

The Munsell opposite hues are more intense in contrast effects than the more commonly used sets of opposites. The Munsell hues tend to create vibrating visual effects when next to each other, as discussed in Chapter 7.

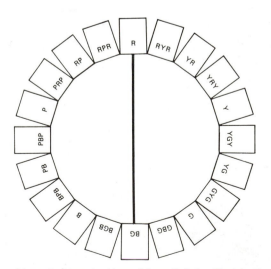

Munsell Opposite Hues (Munsell Color Circle)

An opposite hue contrast is a very commonly used and versatile color effect, especially when used in a full range of values and chromas.

Opposite hues seem to have a strange need for each other, like fire and water. Opposite hues tend to balance each other when used in the correct proportions, as discussed in Chapter 10, Proportions of Hues.

Opposite hues also seem to add unity to a color combination, since all the primary hues are present with any set of opposite hues:

FIGURE 22
page 97

Red and Green = Red and Yellow and Blue
Yellow and Purple = Yellow and Blue and Red
Blue and Orange = Blue and Red and Yellow

Some of the common opposite hues have very pronounced characteristics.

Red and Green are equal in value.
Yellow and Purple are extreme in light and dark contrast.
Red-Orange and Blue-Green are extreme in warm-cool contrast.

The concept of false pair hues is similar to the concept of the opposite hues.

False pairs are sets of two colors opposite each other, though not diametrically, on a color circle. The false pair sets are made up of any subtractive secondary hues. The false pairs hues are:

Orange and Green
Green and Purple
Purple and Orange

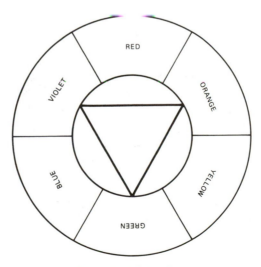

Diagram of False Pairs

The false pairs have the same color effect characteristics as the opposite hues, only weaker, and are less commonly used.

False pairs, like the opposite hues, intermix to a gray. A false pair gray, however, is dominated by the primary hue between the two secondary false pair hues on a color circle. These grayish colors are also called tertiary mixtures.

PROBLEM 7

Use the colored photograph collection from Problem 2 to find examples of the color effects of opposite hues and the false pairs hues. Examine the photographs for the hue pairs, the range of values and chromas present, and the frequency of the presence of a complementary gray.

PROBLEM 8

Use a liquid color agent, such as watercolor, and gradually mix together the common subtractive opposite hues of red and green, yellow and purple, and blue and orange. Apply the original hues and the gradual intermixtures of each set of opposites to the full surface of the blank sides of three-by-five-inch index cards. Try to achieve two gradations between each opposite hue and a complementary gray, or a total of seven cards per each opposite hue pair. When completed, arrange each set of cards in the order of gradation, and observe the effects of opposite-hue intermixtures.

PROBLEM 9

Cut all the painted three-by-five cards from Problem 8 into fifteen one-inch squares. Keep the squares of each color in a separate pile.

Cut three four-by-four-inch smooth-surfaced white mat boards, and lightly pencil a one-inch square grid on each board.

On one board place any two pure opposite hues in diametrically opposite corner squares of the grid, and place the complementary gray in a central square of the same grid. Completely fill the rest of the grid with the remainder of the squares of the gradation, and retain the sense of the effects of the original gradation.

On the second board place another set of pure opposite hues in diametrically opposite corner squares of the grid, and arrange the remainder of squares of the gradation in a design based on the effects of the opposite hues used in a balanced proportion.

On the third board place the final set of pure opposite hues in diametrically opposite corner squares of the grid, and arrange the rest of the squares of the grada-

tion in a design based on the effects of the opposite hues used in an unbalanced proportion.

Lightly glue the final designs in place.

Display and **review** the exercise in relation to the color concepts discussed in this section of the manual.

PROBLEM 10

Select any two Munsell opposite hues from the colored paper collection from Problem 1.

Cut at least eight one-by-one-inch squares from each hue.

Cut one four-by-four-inch square of white smooth-surfaced mat board, and **lightly pencil** a one-inch square grid on the board.

Completely **fill** the grid with a checker design based on the effects of the use of Munsell opposite hues.

Lightly glue the final design in place.

Display and **review** the exercise in relation to the color concepts discussed in this section of the manual.

PROBLEM 11

Follow the procedure outlined in Problems 8 and 9, and use any one or all three sets of the false pair hues.

Display the finished boards so the exercise can be seen often, and **review** the results in relation to the color effects of the opposite hues and false pair hues discussed in this section of the manual.

6

WARM AND COOL HUES

All of the hues can be generally classified as either warm or cool, based on the psychological and physical effects of each hue.

FIGURE 23
page 98

The **warm hues** all contain red and yellow and are generally considered to be:

Red-Orange
Orange
Yellow-Orange
Yellow
Red-Purple
Red
White

FIGURE 24
page 98

The **cool hues** all contain green and blue and are generally considered to be:

Blue-Green
Green
Yellow-Green
Purple
Blue-Purple
Blue
Black

These general **classifications,** however, can change **in relation to** which **hues** are **used in a combination.**

FIGURE 25
page 98

For example, when yellow-green and blue are used together, the yellow-green, which is usually classified as a cool hue, would be a warm hue, since the yellow-green appears warm next to the cooler blue hue.

FIGURE 26
page 98

The classification of **warm and cool hues** can also be changed **with the addition of black and white values.** For example, when a light valued blue and dark valued red are used together, the light blue, which is usually

20

classified as a cool hue, would appear to be a warm hue next to the cooler dark red.

Warm and cool hues appear to move and seem to have particular visual size and weight.

Warm and/or light valued hues and white appear to:

FIGURE 27
page 98

Advance toward the viewer
Radiate, expand, or have eccentric motion
Segregate or separate from each other
Appear larger in size than cool hues
Appear lighter in weight than cool hues
Seem sunny, opaque, stimulating, earthy, near, and dry

Cool and/or dark valued hues and black appear to:

FIGURE 28
page 98

Recede from the viewer
Implode, contract, or have concentric motion
Integrate or blend into each other
Appear smaller in size than warm hues
Appear heavier in weight than warm hues
Seem shadowy, transparent, sedate, rare, airy, and wet

These color effects can be increased when the warm and/or light hues are placed in a cool and/or dark hue environment, or vice versa.

The **visual phenomena of the warm and cool** hues can be used in these ways:

To create the illusion of depth.
To give bright warm and/or light hues a blueish or cool appearance, because objects at a distance appear more blueish.
To make hues which are to appear very distant the lightest in the piece, usually light gray.
To cause shadows of objects to appear to be darker the closer the shadows appear to be.
To give a great sense of depth by a progression of warm to cool hues.

The **movement of warm and cool hues** is most easily accepted from cool hues on the right side of the piece to warm hues on the left side, or cool hues on the lower portion of the piece to warm hues on the upper portion.

FIGURE 29
page 98

In a piece, an advisable practice is to apply the coolest and/or darkest hues first and the warmest and/or lightest hues last.

To cool warm hues add a touch of blue-green and/or black.

To warm cool hues add a touch of red-orange and/or white.

Objects or spaces can be colored with **warm and cool hues to change the characteristics of size and weight.**

Color small spaces or heavy objects with warm and/or light valued hues to give the appearance of larger spaces and lighter objects.

Color large spaces or light-weight objects with cool and/or dark hues to give the appearance of small spaces and heavier objects.

The effects of movement, size, and weight of warm and cool hues can be controlled and varied with changes in values, chromas, and/or proportions in the same manner as that discussed in Chapter 4, Primary Hues.

PROBLEM 12

Select any one hue from the paper collection from Problem 1. Then **select** the three hues on either side of the original hue as determined by the manual color circle in Chapter 11, Color Practices.

Cut two one-inch-wide-by-four-inch-long stripes from the sheet of original-hue paper, and cut one one-inch-wide-by-four-inch-long stripe from each of the other six hues. Keep the stripes in the order determined by the color circle.

Cut two four-by-four-inch smooth-surfaced white mat boards, and **lightly pencil** a one-inch square grid on each board.

Glue the stripes of the original hue to the first grid row of each board. **Add** the remaining three hue stripes from one side of the original hue to one board and the three hue stripes from the other side of the original hue to the other board.

The exercise will demonstrate how warm or cool hues can change in classification in relation to the other hues used in the combination. The original hue will appear cool on one board and warm on the other.

Display the finished boards so the exercise can be seen often, and **review** the related color effects of warm and cool hues discussed in this section of the manual.

PROBLEM 13

Select any three or four warm hues and any eight to ten cool hues, or vice versa, from the paper collection from Problem 1. **Select** a full range of values and chromas of both types of hues. **Cut** at least six one-by-one-inch squares from each sheet of color. Sixty-four squares are needed for the problem.

Cut one eight-by-eight-inch smooth-surfaced white mat board, and **lightly pencil** a one-inch square grid over the entire board.

Arrange a design of the colored squares based on the effects of a few warm hued squares in a dominant cool hued environment, or vice versa.

Lightly glue the final design in place.

Display and review the exercise in relation to the color concepts discussed in this section of the manual.

PROBLEM 14

Use any liquid color agent to completely cover the blank side of ten three-by-five-inch index cards. Cover five cards with five warm hues and five more index cards with five cool hues.

Try to mix a full range of values in the warm and cool hues.

Cut each of the three-by-five-inch index cards into fifteen one-inch squares, and keep each color in a separate pile.

Cut one eight-by-eight-inch smooth-surfaced white mat board, and lightly pencil a one-inch grid over the entire board.

Arrange as many of the colored squares as needed to create a design based on the effects of warm and cool hues to give an illusion of depth.

Lightly glue the final design in place.

Display and review the exercise in relation to the color concepts discussed in this section of the manual.

AFTERIMAGE AND THE SIMULTANEOUS CONTRAST OF HUES 7

The most prevalent color effect is the effect of simultaneous contrast, which is also sometimes called successive contrast.

The effect of simultaneous contrast should always be taken into consideration when color is used.

Simultaneous contrast is the basis of the M. E. Chevreul theory of color contrast and the Josef Albers theory of the interaction of color.

The effect of simultaneous contrast is based on the **theory of afterimage.**

The theory of afterimage is directly related to the Young-Helmholtz theory of the physiology of the human eye discussed in Chapter 2, Physiology of the Eye.

The Young-Helmholtz theory assumes that the eye sees color through three types of color sensors, one type for red, one type for green, and one type for blue.

The Young-Helmholtz theory then assumes that the psycho-physiological phenomenon of afterimage is caused by retinal fatigue. **Retinal fatigue** occurs when the color sensors of the eye are overexposed to any dominant hue for a protracted period of time, of from one to two minutes, under strong light. The situation causes the sensors related to the dominant hue to become dysfunctional or fatigued.

When the dominant hue is removed from sight, only the still-functional sensors transmit color to the brain. Therefore, when the dominant hue is removed, and the eyes are shifted to a neutral surface of white, a floating, colored haze, called an afterimage, appears whether the eyes are open or closed.

This psychophysiological action always occurs to some extent when any colors are seen.

For example, stare at the red square under strong light for one or two

minutes, and then shift the eyes to the outlined white square. A haze of bluish-green color should be seen.

FIGURE 30
page 99

In the example, the red color sensors of the eye are fatigued, so when the eyes are shifted to the white outline square, the blue and green eye sensors transmit color so a haze of bluish-green appears.

There is an afterimage hue to every hue.

The afterimage of Red is Blue-Green or Cyan.
The afterimage of Green is Red-Purple or Magenta.
The afterimage of Blue is Yellow-Red or intense Yellow.

The afterimage hues correspond to the opposite hues of the additive system of primary hues.

The phenomenon of afterimage has been explained as the eye in search of the complement, or an attempt by the eye to restore an equilibrium.

The eye and the brain require the full qualities of light, black, white, and all the primary hues for a harmonious equilibrium of neutral grayness.

The afterimage of each hue can be best determined by reference to the Munsell opposite hues:

Red is the afterimage of Blue-Green.
Yellow is the afterimage of Purple-Blue.
Blue is the afterimage of Yellow-Red.
Red-Purple is the afterimage of Green.
Purple is the afterimage of Green-Yellow.

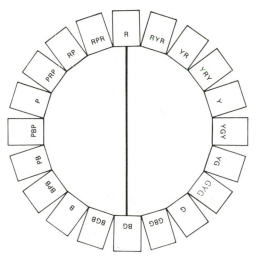

Munsell Color Circle

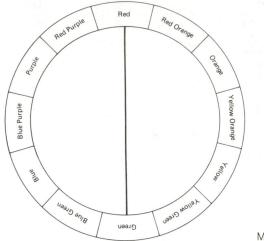

Manual Color Circle

The common subtractive opposite hues are a less precise reference of afterimage colors, but are still usable as a practical reference for afterimages:

Red is the afterimage of Green.
Yellow is the afterimage of Purple.
Blue is the afterimage of Orange.
Red-Purple is the afterimage of Yellow-Green.
Yellow-Orange is the afterimage of Blue-Purple.
Blue-Green is the afterimage of Red-Orange.

The factors of retinal fatigue and afterimage are always present in the use of any hue. The effect is most pronounced with the use of one hue and white.

Afterimages are also present in combinations of two or more hues. The effect of afterimage is only slightly more complex with the presence of a second hue.

When two colors are present, each hue causes an afterimage which affects the other. This visual phenomenon is called **simultaneous contrast** and is present to some extent with any number of hues. The afterimage theory is always as simple as with one hue, only the number of hues adds to the complexity of the color effect.

The effect of **simultaneous contrast** occurs when **two hues** are seen next to or on each other. The afterimage of the dominant hue in a large area washes over onto the smaller area of the other hue, as the hues are seen simultaneously.

afterimage of the black field, while a middle valued gray shape on a dominant white field appears darker due to the black afterimage of the white field.

The simultaneous contrast of values causes dark shapes to be more visible on light grounds.

FIGURE 35
page 99

An example of the **simultaneous contrast of chroma** is that a bright red on a dominant dull green field appears more intense in chroma due to the bright red afterimage of the dull green field. Another example is that a dull red on a dominant bright orange field appears less intense due to the dull blue afterimage of the orange field.

The effect of **simultaneous contrast** can be used to **make the same hue appear to differ** in value and/or chroma when the hue is placed on two different dominant hue fields.

FIGURE 36
page 100

For example, a light gray shape on a dominant dark blue field appears lighter and more orange, while the exact same light gray shape on a dominant light orange field appears darker and blueish. The gray shape is exactly the same gray on both fields, and not like the gray that appears on either dominant color field.

FIGURE 37
page 100

The color effect of simultaneous contrast is not often as dramatic as the examples given. Usually only a very slight change of hue can be achieved, while more obvious changes in value and/or chroma can be achieved.

The effect of simultaneous contrast is the most dramatic with the pure hues. The effect diminishes as other hues and/or light and dark values are added to the piece.

There is another color effect similar to simultanous contrast which is also based on the theory of retinal fatigue. This effect is known as **partitive mixture, adjacent color mixture, optical mixture,** or the Bezold Effect, which is a specific kind of optical mixture.

Optical mixtures are based on the phenomenon which occurs when hues are used in equal proportions adjacent or directly next to each other. The afterimages of the hues mix with each other. A new color mixture appears to the eye and is based on the average of the values and chromas in relation to the proportions of the original hue. The new color will be of equal intensity with the original hues.

The special phenomenon of perception gives the appearance of mixture, though the mixture actually occurs physiologically in the eye.

For example, when a small orange shape is on a large, dominant blue field, the orange shape appears to be more orange, due to the orange afterimage caused by the large blue field. In such a case, the blue color sensors of the eye are slightly fatigued, and the still-functional red and green sensors transmit a yellowish-orange to the brain, which causes the small orange shape to appear more yellowish-orange. If a small **green shape is added** next to the small orange shape on the dominant blue area, both the green and the orange shape are affected by the afterimage of the blue field. The orange shape still appears more orange, and the green shape appears as slightly grayed due to the mixture in the eye of the green and the orange afterimage of the blue field.

FIGURE 31
page 99

FIGURE 32
page 99

FIGURE 33
page 99

The effect of simultaneous contrast occurs in a like manner regardless of how many hues are present, so long as one hue is dominant.

The effect of simultaneous contrast is the result of unequal proportions and is most pronounced with an imbalance of large and small areas of color.

The effect of simultaneous contrast increases the longer the ground color is viewed and/or the more intense the dominant hue is in chroma.

Since the afterimage color is not actually present, but is generated by the eye, the effect of simultaneous contrast causes constantly shifting visual interest.

The opposite hues generate a strong effect of simultaneous contrast.

A stronger simultaneous contrast effect can be achieved with the use of any given hue and the hue on either side of the hue opposite the first hue.

The color effect of simultaneous contrast can have unstable visual results, such as when black ink is printed on orange paper.

Any confusion still left about the color effect of simultaneous contrast might be removed by an everyday example. To show off a suntan to the best advantage, you should wear a light blue shirt or blouse. The dark orange afterimage created by the dominant area of the light blue garment will make your smaller-proportioned face appear more dark orange and tanner. All the colors of the clothes you wear affect your hair, eye, and skin coloring through the effects of afterimage and simultaneous contrast.

Simultaneous contrast can also affect the values and chromas and is present in any hue combination.

FIGURE 34
page 99

An example of the **simultaneous contrast of value** is that a middle valued gray shape on a dominant black field appears lighter due to the white

For example, when yellow dots and blue dots are placed next to each other, the total mass of dots appears to the eye to be neutral gray when viewed from a distance.

The effect of optical mixture is used in weaving, mosaics, carpet design, and Pointillist painting.

FIGURE 38
page 100

The effect of optical mixture is also employed in the **three- and four-color printing processes,** where dot screens of cyan, magenta, yellow, and black are overlapped to create the effect of all the hues. **Color television** images use a continuous triangle pattern of three dots—red, green, and blue—to create the effect of all the hues. In both processes, the eye combines the colors of the dot patterns into areas of continuous color, as discussed in Chapter 4, Primary Hues.

An extreme example of adjacent color mixture or optical mixture is known as the Bezold Effect.

In the **Bezold Effect,** an intense haze of a third hue appears to the eye to vibrate and spread between certain pairs of hues. The Bezold Effect is most pronounced when the additive opposite hues are used at middle values and at intense chromas.

FIGURE 39
page 100

Simultaneous contrast and the derivations of simultaneous contrast are prevalent color effects and must always be considered in works of color. These effects are most prevalent with the primary and secondary hues, the opposite hues, and the warm and cool hues, especially when the hues are pure and at intense chromas.

The effect of simultaneous contrast and optical color mixture can be varied and regulated with changes in values, chromas, and proportions in the same manner as discussed in Chapter 4, Primary Hues.

PROBLEM 15

Select two sheets of any pair of opposite hues from the colored paper collection in Problem 1.

Cut one four-by-four-inch, one three-by-three-inch, and three one-by-one-inch squares from each of the opposite hues selected.

Cut three four-by-four-inch smooth-surfaced white mat boards.

Glue the two four-by-four-inch squares of each opposite hue to a board. Leave the third board white.

Arrange a one-by-one-inch square and a three-by-three-inch square on each

board of opposite hue. **Arrange** the remainder of the one-by-one-inch squares on the white board.

Lightly glue all the squares in place.

Display the finished boards so the exercise can be seen often, and **review** the results in relation to the effects of simultaneous contrast of two hues and/or white discussed in this section of the manual.

PROBLEM 16

Totally **cover** four four-by-four-inch white smooth-surfaced mat boards with any four different hues of intense chromas selected from the colored paper collection from Problem 1.

Then **select** any two or three other hues which have not already been used to cover the four-by-four-inch squares.

Design and **cut** out any small shape four times out of each of the new hues. **Arrange** one shape of each new hue on each of the colored square boards.

Lightly glue the final design in place.

Display and **review** the exercise in relation to the effects of the simultaneous contrast of two or more hues discussed in this section of the manual.

PROBLEM 17

Select one black, one white, and one middle gray piece of paper from the paper collection from Problem 1.

Cut one four-by-four-inch square of these three different-valued papers and mount each color to a four-by-four-inch square smooth-surfaced white mat board.

Use a common one-hole paper punch, and punch three dots out of each of the three different-valued papers.

Arrange three dots, one of each value, in a design on each of the three different-valued square boards.

Lightly glue final arrangements of dots in place.

Display and **review** the exercise in relation to the effects of the simultaneous contrast of values discussed in this section of the manual.

PROBLEM 18

Repeat the process outlined in Problem 17 and use any one hue. **Select** one piece of paper of the hue at an intense chroma, one piece at a weak chroma, and one at an average chroma for a design based on the effects of the simultaneous contrast of chromas.

PROBLEM 19

Select three pieces of colored paper from the collection in Problem 1. Each piece of paper should be of a different light valued, weak chroma hue or three grays tinged with different hues. Cut one one-by-one-inch square out of each sheet of gray paper.

Use the rest of the colored paper collection, and find three hues which will cause the three different gray squares to appear as the same gray when placed on the four-by-four-inch backgrounds.

Mount the final selections on four-by-four-inch smooth-surfaced white mat boards.

Lightly glue the final selection in place.

Display and review the exercise in relation to the effects of color changes due to simultaneous contrast discussed in this section of the manual.

PROBLEM 20

Cut one four-by-four-inch square of smooth-surfaced white mat board.

Use a liquid color agent (gouache is recommended) to cover the entire surface of the board with small painted dots/dabs of any two hues. Continue the dots in layers until, when viewed at a distance of six to ten feet, neither originally painted hue appears, but a new optically mixed hue is developed.

Display and review the exercise in relation to the color concepts of optical mixture discussed in this section of the manual.

PROBLEM 21

Cut one four-by-four-inch square of any hue at an intense chroma from a piece of paper selected from the paper collection from Problem 1.

Cut one four-by-four-inch square of smooth-surfaced white mat board, and glue the colored paper square firmly in place.

Use an opaque liquid color agent (gouache is again recommended) to mix a small quantity of the Munsell opposite hue to the hue of the paper glued onto the board.

Apply the paint to the board in a series of ten to twenty very fine lines to create the Bezold Effect.

Display the finished board so the exercise can be seen often, and review the results in relation to the color concept of the Bezold Effect discussed in this section of the manual.

8

VALUES OF HUES

The effects of values and/or black and white are very basic and commonly known. The effects of value are often forgotten when someone starts to use color. Someone who starts to use color often forgets that blacks, whites, and grays can be used directly as colors. Values are essential to the control of the hues in each of the color effects and in the more advanced and subtle color combinations.

Black is the absence of light.

White is the presence of all light.

FIGURE 40
page 101

Gray absorbs all light, but reflects with equal intensity the hues by which the gray is illuminated.

The blackest black is said to be black velvet. The whitest white is said to be white light. There are many values of gray and two ways to achieve gray. Gray can be made of black and white or made as complementary gray as discussed in Chapter 5, Opposite Hues.

Black, white, and gray are the antithesis of color and are known as **achromatics,** or colors devoid of hue. The achromatics have a great range of commonly known possible effects.

Black and white alone, or an extreme dark and light contrast, are the strongest effect of value. When used alone black and white have bold, rigid, abstract effects of great contrast, with little or no transition and with strong delineation.

Values which range from black to white through a gray scale have more subtle effects of contrast. These gradations or modulations have gentler and slower effects of transition and more delicate delineation than an only black-and-white contrast.

The eye is thought to move from white through gray to black in a piece. The **movement of values** is most easily accepted from white on the right

side of the piece, through grays to black on the left side, or white on the upper portion of the piece to black on the lower portion.

The eye moves quickly through a piece with extreme black-and-white contrasts and transitions. The more gray values added between the black-and-white extremes, the slower and more directed the eye movements can be through the piece. These concepts should be considered as guidelines to the effects of value and movement.

Other important **movements of value** to remember are that white advances and black recedes from the viewer, while gray is somewhat neutral in movement. The movement of achromatics is discussed in Chapter 6, Warm and Cool Hues.

The effects of value are quite dominant and function in a similar manner even with the addition of the hues. Value effects are equal, if not sometimes possibly stronger, than the other color effects.

The addition of **values to a piece** is one of the primary ways to balance or harmonize extreme color effects and color combinations when needed or desired.

In a composition based on the effects of value, the suggestion is to use only a few hues.

FIGURE 41
page 101

When black, white, and gray are used in combination with valued hues, the values of the hues and the achromatics should be different, or simultaneous contrast will adversely affect the achromatics.

When gray is used alone, the hues used with the gray can be of equal value.

Gray and dull values gain in vividness by the hues which surround the grays, but these values cause the hues to appear weaker.

FIGURE 42
page 101

The stronger the value contrast of hues, the more extreme will be the color effect. Equal-valued hues are very weak in visibility.

The effect of warm and cool hues is the most difficult color effect to balance with values, since warm and cool hues are similar in extremes of contrast and movement.

Yellow is said to be the lightest hue and purple is said to be the darkest of the pure hues.

FIGURE 43
page 101

PROBLEM 22

Go to an art supply store and **obtain** one sheet of good-quality white drawing paper with a slightly rough surface. The paper should be at least eight by fifteen inches in size.

Cut three strips from the drawing paper, each five inches wide and eight inches long, and **lightly pencil** eight one-inch-wide stripes on the entire length of each strip.

On the **first strip** use only a black dry color agent (a colored pencil is recommended) and tone the first stripe of the strip solid black, and leave the stripe on the other end of the strip white. Tone the other six stripes in between the black and white stripes with the appropriate gray values.

On the **second strip** repeat the same procedure as with the black pencil, but this time use any one hue except yellow. Yellow is the most difficult hue to achieve in a full range of values.

On the **third strip** fill each of the stripes with a different hue in the order of red, orange, yellow, green, blue, blue-green, purple, and red-purple.

Display the strips one beneath the other with the darkest value of each strip to the left. Observe the relationships of the effects of the values of the three strips.

PROBLEM 23

Cut the whole first strip of gray values and the whole second strip of a valued hue from Problem 22 into one-by-one-inch squares. Keep each color in a separate pile.

Cut three four-by-four-inch smooth-surfaced white mat boards, and **lightly pencil** a one-inch square grid on each board.

On the **first board** arrange only the black and the darkest gray valued squares in an equalized checkered design of regularly intermixed dark and light values. The design should be based on the effects of the contrast of transitions of values.

On the **second board** arrange the remainder of the gray valued squares. Do not use the white squares in an equalized checkered design of regularly intermixed dark and light values. The design should be based on the effects of the contrast of transitions of values.

On the **third board** arrange the squares of the valued hue strip in a checkered design based on the effects created of directional movement by a full range of values.

Lightly glue the finished designs in place.

Display the finished boards so the exercise can be seen often, and **review** the results in relation to the effects of value discussed in this section of the manual.

PROBLEM 24

Cut the whole multihued strip from Problem 22 into one-by-one-inch squares, keeping each hue in a separate pile.

Cut one four-by-four-inch smooth-surfaced white mat board, and **lightly pencil** a one-inch square grid over the entire board.

Arrange any and all of the hue squares and the remainder of the gray valued squares from Problem 23 in a design based on the effects of the related changes in values and hues.

Lightly glue the final design in place.

Display and **review** the exercise in relation to the color concepts of values discussed in this section of the manual.

CHROMAS OF HUES

The effect of contrast or transitions of chroma is not often taken into consideration when someone starts to use color. Chroma plays a strong role in color decision since it is one of the three attributes of any color.

Chroma, as discussed in Chapter 3, The Three Attributes of Color, is the intensity, purity, or saturation of a hue at a given value.

FIGURE 44
page 102

The contrast effect of **chroma** is the **strongest** in a combination of very intense chromas and dull chromas. The contrast effect of chroma can be weakened by the use of chromas of equal intensity, either all strong and intense or all dull and muted.

Each effect of the contrast of chroma creates a certain **mood.** All intense chromas give a rather harsh effect, while all dull chromas give a rather calm effect. The combination of strong and weak chromas gives a more normal effect. The use of hues of all equally strong chromas adds to visibility.

FIGURE 45
page 102

The effects of **chroma** are often used to **simulate light moods.** Chroma, rather than value, best simulates light, since light is thought of in terms of intensity, such as bright light or low light. Light effects are directly related to the creation of moods. Bright, intense chromas give the sense of direct or powerful light sources which are very dramatic. Weak chromas give a flat, even light which creates a placid or neutral sense. Most light situations are a combination of strong, average, and weak chromas.

The eye can be directed through a piece by the placement or **transition of chromas.** The eye will usually move from weak chroma areas to average chromas and stop at strong chroma areas of a piece. Chroma movements are best accepted from weak chroma on the right to strong chroma on the left or from weak chroma in the upper to strong chroma in the lower portions of a piece.

Strong chroma advances and tends to catch the eye first. Weak chromas recede and are rest points for the eye.

The chromas of hues can be varied and regulated by the addition of more pure hue to a gray, more gray to a pure hue, or through the proportions discussed in Chapter 4, Primary Hues.

FIGURE 46
page 102

PROBLEM 25

Use a liquid color agent (gouache is highly recommended) to mix three separate amounts of gray pigment, one gray at a light value, one gray at a middle value, and one gray at a dark value.

Select three different hues, and mix a small amount of each hue.

To one of the gray values, add two drops of one of the hues, and apply enough of the mixture to completely cover the blank side of one three-by-five-inch index card. Then add two to four more drops to the new mixture, and apply to another index card. Continue the procedure for a total of six cards, and vary the chromas at any rate from very weak to very strong.

Repeat this full procedure with each of the other gray values and with the other two hues.

Cut all of the three-by-five-inch cards into one-inch squares, and keep each color in a separate pile.

Cut four four-by-four-inch smooth-surfaced white mat boards, and lightly pencil a one-inch square grid on each of the boards.

On the first board arrange sixteen squares of one hue in a design which demonstrates the effects of a full range of chroma movement.

On the second board arrange sixteen squares selected from all three hues mixed. Use only the squares of weak chroma. Create a design based on the effect of the use of chromas of weak contrast.

On the third board arrange sixteen squares selected from all three hues mixed. Use only the squares of strong chroma. Create a design based on the effects of the use of chromas of strong contrast.

On the fourth board create a design of all three hues mixed. Use a combination of weak to strong chromas. Base the design on the effects of the movement of chromas.

Lightly glue the final designs in place.

Display the finished boards so the exercise can be seen often, and review the results in relation to the effects of chroma discussed in this section of the manual.

10

PROPORTIONS OF HUES

All of the color effects are affected by the proportions in which the hues are used. Proportions are the relationships of the quantities of areas of each hue.

When the color effects are used, the proportional relationships are usually those of large color areas to small color areas, or vice versa.

The **two systems** which follow were developed by **Goethe** and **Munsell** and can be used as guidelines to achieve a balance of proportions of colors.

FIGURE 47
page 103

The **Goethe System,** based on **balance of the proportions** of opposite hues, is called the Harmonious Scale of Areas of Primaries and Secondaries:

Yellow 9
Orange 8
Red 6
Purple 3
Blue 4
Green 6

Each hue on the scale is assigned a rate number. In theory, to balance the proportions of the two opposite hues, simply invert the rate numbers to determine the quantities needed.

For example, to create a balanced mixture or complementary gray from yellow and purple paint, invert the rate numbers and mix three parts of yellow paint to nine parts of purple paint. The proportional ratio of nine to three can be mathematically reduced to a ratio of three to one or three-quarters to one-quarter.

The same scale of ratios can be used to balance the proportions of areas of given hues to achieve a balanced optical mixture of neutral gray.

38

For example, for three inches of yellow area, nine inches of purple are needed to achieve a visually balanced color effect. The proportional ratio of nine inches to three inches can be reduced to three inches to one inch, or three quarters of an inch to one quarter of an inch. The proportional ratios of the opposite hues are:

Yellow to Purple: 9 to 3, 3 to 1, ¾ to ¼
Orange to Blue: 8 to 4, 2 to 1, ½ to ¼
Red to Green: 6 to 6, 1 to 1, ¼ to ¼

These ratios are only valid for the pure primaries and secondaries.

With more complex hues, use the **Munsell System to determine the balance of proportions.** In the Munsell System the chroma number is multiplied by the value number of the Munsell Color Notation in each hue.

For example,

Y$^8/_{12}$ is 8 × 12 or 96
PB$^5/_{10}$ is 5 × 10 or 50

FIGURE 48
page 103

Simply invert the products to find the ratio of the balance of proportions:

50 parts of Y$^8/_{12}$, to 96 parts of PB$^5/_{10}$, or a ratio of five parts to eight parts.

FIGURE 49
page 103

The Munsell formula of proportions works with any two hue notations in the Munsell System.

With three or more hues the concept of proportions becomes more mathematically difficult with each additional hue. There are mathematical ratios for these cases. However, the process is simpler if the basic concept is kept in mind and the proportions are adjusted visually and manually.

There is a very **general rule** about **multicolored proportions** which can be used only as a guideline. Hues, values, and chromas of strong contrast should occupy the smaller areas of a piece, while hues, values, and chromas of weak contrast should occupy the larger areas of a piece.

PROBLEM 26

Select one sheet each of any of the opposite hue pairs of the Harmonious Scale of Areas from the colored paper collection from Problem 1.

Cut eight one-inch-wide by eight-inch-long stripes from each opposite hue.

Eight-inch board with grid

Cut one eight-by-eight-inch smooth-surfaced white mat board, and **lightly pencil** a one-inch square grid on the board.

Arrange the stripes of the two opposite hues on the board in a design of proportions suggested in the Harmonious Scale of Areas.

Lightly glue the final design in place.

Display and **review** the exercise in relation to the effects of the Goethe System discussed in this section of the manual.

PROBLEM 27

Select two sheets of any two hues from the colored paper collection from Problem 1.

Cut eight one-inch-wide by eight-inch-long stripes from each hue.

Code the hue, using the Munsell color charts in the Color Index.

Cut one eight-by-eight-inch smooth-surfaced white mat board, and **lightly pencil** a one-inch square grid on the board.

Then **arrange** the stripes of the two hues in a proportionally balanced design. Use the Munsell formula for proportions.

Lightly glue the final design in place.

Display the finished boards so the exercises can be seen often, and **review** the results in relation to the effect of proportions discussed in this section of the manual.

11
COLOR PRACTICES

Wassily Kandinsky advises someone who starts to work with color not to try to be profound or complex to begin with.

Someone who starts to work in color should deal with color directly and with a simple knowledge of the color effects and personal psychological color associations.

An easy way to achieve these simple yet thorough working methods is to follow the advice of Eugène Delacroix. Delacroix found that it was invaluable to have a color circle near him when he worked.

Color circles do not solve color problems. Color circles help to jog the memory as to all the possible color effects and combinations.

A color circle also encourages the use of a greater range of hue combinations. Without a color circle of some sort, the same color effects and combinations are likely to be used repeatedly.

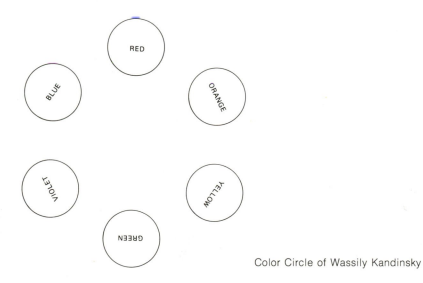

Color Circle of Wassily Kandinsky

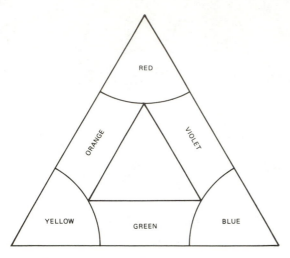

Color Triangle of Eugène Delacroix

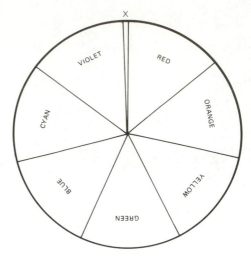

Color Circle of Sir Isaac Newton

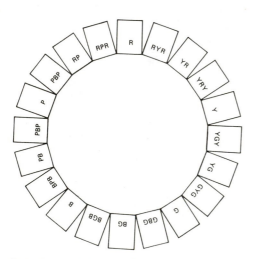

Color Circle of Albert H. Munsell

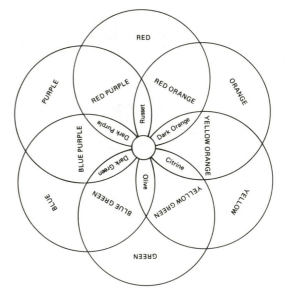

Color Circle of George Field

A color circle should be a personally designed tool, since each artist has slightly different needs. Do not hesitate to design a color circle which will fit the properties you need.

The color circle provided in this manual (page 43, lower right) is a hybrid design of the color circles of Johannes Itten, Paul Klee, and Johann Wolfgang von Goethe.

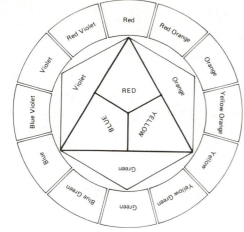

Color Circle of Johannes Itten

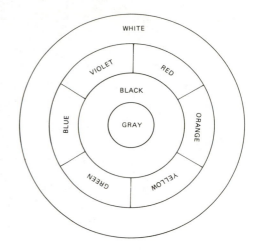

Color Circle of Paul Klee

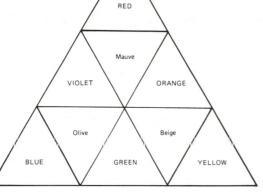

Color Triangle of Johann Wolfgang von Goethe

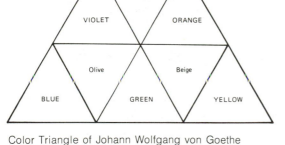

Manual Color Circle

The color circle in the manual shows the common subtractive primary hues in the **first ring** of colors and the secondary hues in the **second ring** of colors.

FIGURE 50
page 104

The **third ring** of colors shows the primary and secondary hues again and the intermixtures.

The **small circles** on the second ring of colors are the tertiary mixtures. These small circles denote the possible intermixtures beyond those of the primary and secondary hues.

The **gray circle** in the center of the color circle indicates that gray can be used as a color and also acts as a focus for the intermixtures of the opposite hues or any two hues on the color circles, as discussed in this section of the manual.

The **black ring** and the **white ring** are reminders that black and white can be used as colors or for values, and show the importance of black and white as environments for the hues.

If this color circle does not satisfy your specific needs, try another one or design one of your own combination from the information available in other color circles.

A copy of the color circle you will use should be placed in sight near where you work.

The color circle should be protected in clear plastic, so the circle will become a tool you are not afraid to damage.

You will find a color circle an invaluable tool to start to make color decisions with.

Just to look at the color circle is not helpful. You must use the circle to make some decisions.

The first decision to be made is called the **key hue.** The key hue is the hue you start with, or the most dominant or important hue in the final piece.

Once you have located the key hue on the color circle, you should be able to see the possible color choices quickly and decide which to use.

For example, if you select red as your key hue, and you use the color circle in this manual, you will be reminded of:

the effect of the other primary hues, yellow and blue
the effect of the opposite hues, red and green
the simultaneous contrast effect of red and green
the tertiary of red, mauve
of black, white, and gray
and of the possible color schemes discussed in Chapter 13, Color Schemes.

From all these possibilities you should then select the one most appropriate to your color problem.

When you start to work in color, decisions are difficult to make in your mind's eye. Answers to color problems are most easily found on the color circle. Learn to refer to your color circle until you think more naturally in color.

There are **four procedural problems** encountered when someone starts to work with color. Each procedure has special characteristics and methods to deal with the problem.

Colors Worked Into Form

For example, in collage, weaving, dyeing, and painting.

Although the procedure may sound strange and complicated, the process is actually very easy. All colors, due to the hue, value, and/or chroma, seem to require a certain amount of area and orientation in a piece so the colors do not appear cramped or out of place. Therefore, a general, rough placement and balance of color areas of a piece is advisable before the actual contours of each colored shape are decided. Let the colors decide the forms. The procedure causes less frustration and assures a more accurate proportional balance.

Given Forms Worked Into Colors

For example, in color photography, painted sculpture, embroidery, textile design, and ceramic glazing.

Forms worked into colors is actually a more difficult color procedure, since the proportions of the shapes have already been determined by the outlines. You must concentrate on the adjustment of the values and the chromas of the hues until the colors rest properly in the predrawn shapes. The procedure is not impossible. It merely consumes more time, especially when you start to work with color, since you may have to readjust the colors within the outlines more than once. As you come to understand how to use the color effects, you will find less frustration with the problem.

Mixed Colors

To mix your own colors is superior in all cases to the use of given colors, no matter what the color agent. Although the procedure consumes more time and takes some practice, the range of possible colors is better. If you mix your own colors it is much easier to work out the problems and procedures which deal with colors and forms. The suggestions which follow should be kept in mind when you mix your own colors.

FIGURE 51
page 105

Any color may be mixed with black, white, and gray or any other color, therefore innumerable intermixtures are possible.

When you start to intermix colors, use only small amounts of a color agent, so as not to waste materials.

FIGURE 52, 53
page 105

Brighten colors with more than white; also use yellow and red-orange.

Darken colors with more than black; also use blue, purple, and/or red.

FIGURE 54, 55
page 105

Diluting colors with white can make the colors colder and lighter.

Diluting colors with black can take away the light and deaden the color.

FIGURE 56
page 105

Diluting colors with black and white or gray can dull or neutralize the colors.

FIGURE 57
page 105

Diluting colors with opposite hues can make the colors duller, but vivid.

Refer to a color circle for the intermixtures of secondary hues, opposite hues, and false pair hues, as discussed in Chapter 5, Opposite Hues.

The results of the intermixture of any two hues on a color circle can be predicted by a line drawn between the hues. The center point of the line will be the color of the intermixture and can be seen in relation to the rest of the color circle. For example, orange and yellow-green intermix to give a very slightly grayish yellow-orange-yellow.

Intermix the colors already on your palette into new colors for easy harmony.

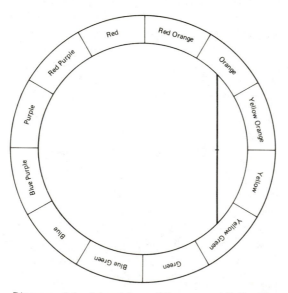

Diagram of the Intermixture of Orange and Yellow-Green

If the colors appear to clash, sometimes a helpful procedure is to inter-mix some of each color into each other color.

Most browns contain hues from yellow to red-purple on the color circle.

A helpful practice is to state aloud the name of the color to be mixed—for example, a blueish-orangish-pink or a red-green-black. To achieve these intermixtures, simply mix together the stated colors in the appropriate proportions.

Try to approach each piece of work with a different and new set of color problems and concepts.

FIGURE 58
page 105

FIGURE 59
page 105

FIGURE 60
page 105

Given Colors

Given colors are color agents which, for some reason, cannot be physically changed, such as most sheet color agents. Color problems are more difficult to solve when you have to work with given colors, since you cannot change the hue, value, or chroma, but only the proportions of the shapes. Whenever possible, work out a rough color sketch in a more facile medium before you attempt to work with the given colors. The given colors can also be worked in an impermanent placement exercise before the piece is constructed. These procedures prevent the need to continually reshape and adjust the sizes and positions of forms in the final piece.

Most of the problems you will encounter when you start to work in color, other than media, will involve one of these four procedures or some combination of these procedures.

The most difficult problem is the combination of given colors worked into given forms. With practice, however, even the difficult procedures will become more possible.

PROBLEM 28

Cut one eight-by-eight-inch square rough-surfaced white mat board, and lightly pencil a one-inch square grid over the board.

Use a dry color agent (oil crayons are highly recommended) and select one hue as the key hue. Apply the key hue to five different areas of the board, and cover four squares of the grid each time.

Using a color circle to make decisions, select five more hues, and fill in the rest of the grid with these hues in any number or position of squares to achieve a well-proportioned design.

Do not hesitate to intermix the hues directly on the board.

Display the finished board where the exercise can be seen often, and **review** the results in reference to the concept of colors worked into forms as discussed in this section of the manual.

PROBLEM 29

Cut one eight-by-eight-inch square smooth-surfaced white mat board, and **lightly pencil** a one-inch square grid over the entire board.

Select one sheet of any hue from the colored paper collection from Problem 1.

Using a color circle to make decisions, select six more sheets of color in relation to the originally selected sheet, which is the key hue.

Cut two one-by-eight-inch stripes from the sheet of the key hue, and **lightly glue** them on the board in any two rows of the grid.

Cut one one-by-eight-inch stripe from each sheet of the other hues, and arrange on the design with the two key hue stripes.

Work the design so the colors are proportionally balanced and no hue form is dominant, not even the key hue form dominant in the design. When viewed at a distance of six to eight feet, the design should have a neutral appearance with no hue form dominant.

If the form of one or more of the selected hues is dominant, **select** another sheet of the hue at a different value or chroma until each hue fits in each stripe form with proportional balance.

Lightly glue the final design in place.

Display and **review** the exercise in relation to the concept of given forms worked into color discussed in this section of the manual.

PROBLEM 30

Cut two eleven-by-eleven-inch square rough-surfaced white mat boards, and **lightly pencil** a grid of one-inch squares on each board.

Use a liquid color agent to mix a moderate amount of each of the ten colors in the sequence of red, orange, yellow, green, blue, purple, red-purple, black, white, and gray.

Leaving the first square in the corner blank, apply each of these colors in a separate square of the first cross row of the grid, in the given sequence.

Repeat the application of colors down the first left column of the grid. Again leave the first square blank. Apply the colors in the same sequence.

Eleven-inch board with grid

Use the top row and the first left column of the grid as a guide. Fill each of the rest of the squares of the grid with the color intermixture indicated at the intersection of squares. For example, mix red first with red, then orange, then yellow, then green, then blue, then purple, then red-purple, then black, then white, and finally gray.

Move to the next square in the first row of the grid—orange—and mix the orange with each of the other colors in the first left column—red, orange, yellow, green, blue, purple, red-purple, black, white, and gray.

Continue this procedure until the entire grid is filled with the appropriate intermixtures.

On the **second board** fill the entire grid with intermixtures of your own choice with the remainder of the color agent from the first board.

Try to **follow** some of the **guidelines** discussed in this section of the manual about mixed colors.

Display and **review** the exercise in relation to mixed color as discussed in this section of the manual.

PROBLEM 31

Cut one eight-by-eight-inch square smooth-surfaced white mat board out of the center of a twelve-by-twelve-inch square mat board that is white on one side and black on the other.

Select six sheets of various hues, values, and chromas from the colored paper collection from Problem 1. **Designate** one color as the key hue.

Lay all six sheets on a large flat surface so that all the colors show and intersect at right angles to one another.

Place the twelve-by-twelve-inch black frame mat board over the paper so that all the colors are visible in the eight-by-eight-inch viewing space.

Slide the colored papers around on each other until an appropriate, proportioned design appears in the viewing space.

Remember to keep the **key hue** obvious and to keep the whole design at right angles.

Once you determine how much area and the form each given color of the design requires, carefully **cut** out the paper and **transfer** the exact design onto the eight-by-eight-inch white mat board.

Lightly glue the final design in place.

Display and **review** the exercise in relation to the concept of given colors discussed in this section of the manual.

12

COLOR COMBINATIONS

A color combination is two or more colors which are somehow related. All color combinations have a **key hue,** which is the hue started with or the dominant or important hue of the final piece.

Prejudices against colors and color combinations shift and change almost daily.

There is no such thing as an ugly color combination. All color combinations can be controlled by use of the color effects.

There are many **good references** for color combinations in the daily environment, from the colors in the backyard, to a pile of colored dishes in the sink, to even the color of a pet.

Be conscious of color combinations which catch the eye, and record the colors in your mind for later use. Think aloud when you analyze these environmental color combinations to cement the record of the combination in your memory.

Nature is one of the best **references** for color combinations and the color effects. Nature provides an endless array of usable color combinations. Due to the vastness of natural coloration, references to nature for color combinations are advisable only when the key hue is known. You will then be able to eliminate many of the examples and to see the combinations possible with the key hue.

Another good **reference** to develop your ability to select color combinations is your **wardrobe**. People seldom have real difficulty in devising good color combinations in dress. Even though your wardrobe may not be vast, you can still use the concept of dress to put colors together.

For example, if you wear a light blue blouse or shirt and a dark blue coat, what color tie or scarf would you select to create the effect you desire? Although the idea may sound too simple at first, dress has proven a good place to start to think about color combinations. Most people have a natural and unconsciously correct ability to dress in colors.

When you start to think in color, think through a piece in relation to dress. The large dominant area of the key hues equates to a shirt or blouse and/or a coat. The smaller areas of the color combination equate to the tie or scarf you would wear to create the effect you want. These choices of clothes are often correct for a piece, with only slight modifications in value, chroma, and/or proportions.

The simple process of dressing can lead to subtler color combinations, since clothes do not always come in pure hues. The method can also start you to think of color synesthesia, such as dark, velvety blue or silky, light orange.

Analysis of your present personal color choices in your environment and artistic palette is helpful. Break your personal color combinations down into the colors and effects you most often use. The analysis will allow you to see which color combinations and effects are already natural to you. The exercise can help you judge how often you use the same combinations and indicate new directions for you to consider in your color development.

Another, more direct method of learning good color combinations is to compose the worst possible color composition you can. Through this exercise you will discover which color combinations do not work, and then you should be able to use antithesis correctly.

Awareness of trends in color combinations is also somewhat important. The more familiar you are with different combinations, the better prepared you will be to appreciate new combinations.

There are several good sources of color combinations used by artists and designers of the past and present.

Fashion and costume books and magazines are a valuable source of color combinations. So are clothes depicted in paintings.

Other good sources of color combinations are interior decoration magazines and books on the history of decoration.

Art and design pieces in books, magazines, or museums are invaluable sources for color combinations.

When these sources are used, try to concentrate on the color combination effects before the subject matter. Although this is sometimes difficult to do, you will remember or record the color combinations better.

Munsell attempted to categorize the possible color combinations he had seen into a system he called **color scores**. His color scores are derived from study of the color combinations in such objects as butterflies, flow-

ers, Persian rugs, and Japanese prints. The color scores are to be used as a guide to the discovery of color combinations. Each color score is based on the selection of certain chips from the hue charts of the Munsell Color Tree discussed in Chapter 3, The Three Attributes of Color.

There are **nine Munsell Color Scores**.

The Vertical Score is simply a monochromatic color combination from one hue chart, with all the chips at the same chroma step but each chip on different value levels. The selection of chips starts with a key hue value chip and moves up and/or down the value scale of a hue chart at a given chroma. The score is a value-run of a hue, but all of the same chroma, either weak, medium, or intense. The best results are achieved by a selection of chips at even or equal-distance value levels.

FIGURE 61
page 106

The Horizontal Score is also a monochromatic color combination from one hue chart, with all the chips selected on the same value level but each chip of different chroma steps. The selection of chips starts with a key chroma chip and moves in and/or out of the chroma step of a hue chart on a given value. The score is a chroma-run of a hue on any one value level, either dark, middle, or light. The best results are achieved by a selection of chips at evenly spaced steps of chroma.

FIGURE 62
page 106

Munsell Vertical Score

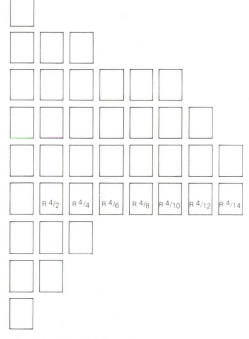

Munsell Horizontal Score

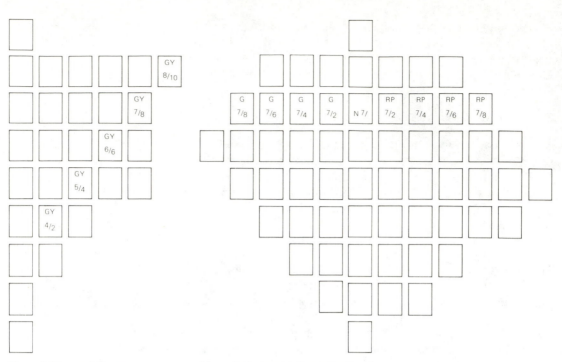

Munsell Diagonal Score

Munsell Horizontal Cross-Section Score

Within the diagonal score grid: GY 8/10, GY 7/8, GY 6/6, GY 5/4, GY 4/2

Within the horizontal cross-section grid: G 7/8, G 7/6, G 7/4, G 7/2, N 7/, RP 7/2, RP 7/4, RP 7/6, RP 7/8

FIGURE 63
page 106

The Diagonal Score is also a monochromatic color combination from one hue chart, with all of the chips selected from any diagonal sequence of chips on the chart of changing values and chromas. The score starts with a key chip of a certain value and chroma and moves up and/or down in any diagonal direction from the key chip. The score is like a value-run, but also has simultaneous gradations in chromas. The best results are achieved by a selection of chips at evenly spaced steps on the diagonal.

FIGURE 64
page 106

The Horizontal Cross-Section Score is a score of opposite hues with all the chips selected from the same value level of two opposite hue charts, at different chromas, plus the chip from the neutral gray pole. The score begins with any key chroma chip of one hue, on a certain value level, and moves in a horizontal line on that value level through the neutral gray pole to any chroma chip in the consistent value level in the opposite hue chart. The score is like two chroma-runs back to back with the common neutral gray chip between. The best results are achieved by a selection of chips which go out equal distances from the neutral pole in both hues—for the best balance.

FIGURE 65
page 106

The Diagonal Cross-Section Score is also a color score of opposite hues, with all chips selected from any diagonal sequence value and chromas

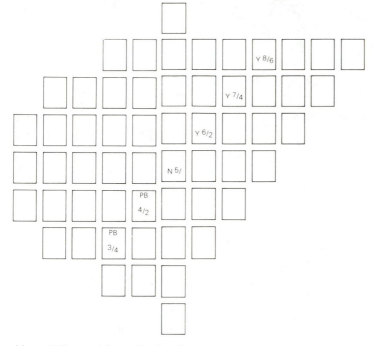

Munsell Diagonal Cross-Section Score

selected from two opposite hue charts, plus the chip from the neutral gray pole. The score starts with any key chip at one value and chroma in one hue and moves in a diagonal direction up and/or down through the neutral gray pole into the opposite hue at a continuous diagonal to the key chip. The score is like two diagonal scores back to back with the common neutral gray chip between. The best results of the score are achieved by a selection of evenly spaced chips which go out equal distances from the neutral pole in both hues—for the best balance.

The Circular Score is the first of the multihue or rainbow-like scores with any number of different chips selected from sequential hue charts arranged around the neutral pole, with each different hue chip of the same value level and same chroma step. The score starts at any key hue chip at a given value and chroma and moves in a circle from one hue chart to another hue chart in either direction through all of the hue charts of the color circle, or just some of the hue charts in order, or every other hue. All the different hue chips must be of the same value and chroma. The score results in some quantity of a rainbow sequence of hues, and all the hues have the same value and chroma. The best results are achieved by a selection of any number of or all of the hues in the sequence, or every other one.

FIGURE 66
page 106

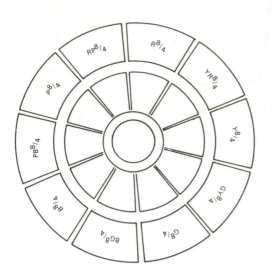

Munsell Circular Score

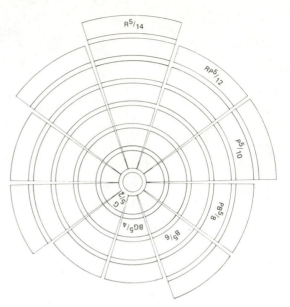

Munsell Flat Spiral Score

FIGURE 67
page 106

The Flat Spiral Score is a score movement through all of the hues of the color circle, with chips selected of the same value level but at different chroma steps. The score begins as a simple spiral movement from a key value chip on the neutral pole and moves around the color circle, but moves out one chroma step with each progressive hue. The score is another rainbow-run with a display of chroma change, which is either weak to strong or strong to weak. The best results are achieved by a selection of any number of or all the hues in the sequence, or every other one.

FIGURE 68
page 106

The Helical Score is a score movement through all of the hues of the color circle, with chips selected of the same chroma step but of different value levels. The spiral movement begins at a chosen distance from the neutral pole at a key chroma step, moves around the color circle, and continues up or down in value levels with each progressively selected hue chip. The score is another rainbow score, but all the different hue chips have the same chroma but different values from dark to light or vice versa. The score can be used in the same manner as the circular score and the flat spiral score.

FIGURE 69
page 106

The Three-Dimensional through Psychological Space Score is another rainbow score in which all three attributes, hue, value, and chroma, change. The score is not as complex as it sounds. The movement starts with the selection of a key value chip on the neutral gray pole out or in chroma and simultaneously up and down in value with each progressive hue. The score is really another rainbow-run, but with the most interest and very lifelike, since the score changes in both value and chroma simultaneously. The score is best used like the other multihued scores.

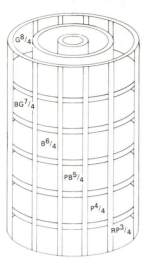

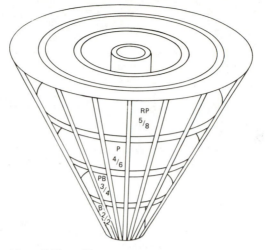

Munsell Helical Score | Munsell Three-Dimensional Through Psychological Space Score

PROBLEM 32

Decide on a key hue you would like to work with. Then select three different objects in nature where the same key hue is the dominant color, such as a flower, an insect, and a stone. Real objects are preferable to photographs.

Use any liquid color agent (watercolor is highly recommended) and duplicate as closely as possible the color combinations of each of the three natural objects. Record each of the colors in each of the three objects on separate one-by-one-inch squares. Make sure to record the full range of hues, values, and chromas of each object, and keep the squares of each object in separate piles.

Cut three square white smooth-surfaced mat boards large enough to accommodate each color record. **Lightly pencil** a one-inch square grid on each of the three mat boards.

Arrange each color record separately into an appropriate design on each of the boards. Use black, white, and gray squares to completely fill the grid.

Lightly glue the final arrangements in place.

Display the finished boards so the exercise can be seen often, and **review** the results in relation to the color combinations discussed in this section of the manual.

PROBLEM 33

Decide on a key hue, the dominant color in your wardrobe of clothes. Select the key hue from the colored paper collection from Problem 1.

Cut three two-by-four-inch stripes of the sheet of the key hue.

Cut three four-by-four-inch square white smooth-surfaced mat boards, and **lightly pencil** a one-inch square grid on each of the boards.

Using the rest of the clothes in your wardrobe as a reference, select three more colors you might wear with the key hue color. Select these three colors from the colored paper collection.

Cut three one-by-four-inch stripes and three one-by-one-inch squares out of each of the three new colors.

Arrange the two-inch-wide key hue stripes, two of the one-inch stripes and one of the one-inch squares on each of the three boards. Record the possible color combinations.

Lightly glue the final arrangements in place.

Display and **review** the exercise in relation to the color concepts discussed in this section of the manual.

PROBLEM 34

Use the color agent you most often use to complete a full-color piece in the manner you most frequently use.

When the piece is finished, **select** all of the colors in the piece from the colored paper collection from Problem 1.

Cut a one-by-one-inch square from each of the colored paper sheets.

Cut a square white smooth-surfaced mat board large enough to accommodate all of the one-inch squares. **Lightly pencil** a one-inch square grid over the entire board.

Arrange the one-inch squares on the board in an analytical design that best duplicates the coloration of your original piece. Do not hesitate to cut additional squares to complete the full grid design.

Lightly glue the final design in place.

Display and **review** the exercise in relation to the color concepts discussed in this section of the manual.

PROBLEM 35

Select five different colors from the colored paper collection from Problem 1.

Cut a one-by-four-inch stripe and a two-by-one-inch rectangle from each of the five colored sheets.

Cut two four-by-four-inch square white smooth-surfaced mat boards, and **lightly pencil** a one-inch square grid on each board.

On the **first board** use any combinations of stripes and rectangles to create the worst color design you can.

On the **second board** use any combination of the remainder of the stripes and rectangles to create a well-proportioned color design.

Lightly glue the final designs in place.

Display and **review** the exercise in relation to the concept of nature as a color combination reference discussed in this section of the manual.

PROBLEM 36

Select a simply colored art or design object from any period in history.

Use any color agent, cover a one-inch square with each of the hues, values, and chromas in the object, and duplicate the full range of color combinations in the object.

Cut a square white smooth-surfaced board large enough to accommodate the number of squares generated by the record of the colored object. **Lightly pencil** a one-inch square grid over the boards.

Arrange the squares in an analytical design that best represents the color combinations of the art or design object selected.

Lightly glue the final arrangement in place.

Display and **review** the exercise in relation to the concept of sources of color combination trends discussed in this section of the manual.

PROBLEM 37

Select one colored photograph from the photograph collection of Problem 2 which best represents each one of the nine Munsell Color Scores.

Display the photograph so the exercise can be seen often, and **review** the results in relation to the Munsell Color Scores discussed in this section of the manual.

13

COLOR SCHEMES

All color combinations are color scheme problems, or problems of which color goes with which colors. The permutations of all of the hues is endless, and so you might need a scheme or systematic plan to start to approach color combinations and interactions.

There are several commonly known color schemes or plans.

Achromatic Color Scheme

A hueless scheme of black, white, and grays.

Monochromatic Hue Scheme

A color scheme constructed in all one hue, with variations in only the values and/or chromas of the hue. The vertical, horizontal, and diagonal scores discussed in Chapter 12, Color Combinations, are all versions of monochromatic color schemes.

Monochromatic Hue Scheme with Black, White, and Grays

A color scheme constructed all in the values and chromas of one hue, but accented with black, white, and/or gray values. The values and chromas of the hue should be decidedly different in contrast to the achromatics.

Analogous Hue Scheme

A harmonious color scheme of hues adjacent to each other on a color circle. The scheme is constructed of any set of three to six adjoining hues adjacent to one or both sides of a key hue. Any number of hues may be used so long as the hues are not opposite hues to the key hue or to each other.

For example:

Key hue: Red
 Red-Purple
 Purple
 Blue-Purple
 Blue
 Blue-Green—opposite to red, unusable

 Blue
 Blue-Green
Key hue: Red
 Red-Orange
 Orange
 Yellow-Orange—opposite to blue, unusable

Analogous hues may be used in any combination of values and chromas. An analogous hue scheme can be likened to the use of any four to six hue sections of a circular score, a flat spiral score, a helical score, or a three-dimensional through psychological space score, as discussed in Chapter 12, Color Combinations.

Analogous Hue Scheme with Dominant Hue

This is a second version of an analogous hue scheme, with any one of the adjacent hues in a dominant proportion of the piece.

Analogous Hue Scheme with Opposite Hues Accent

A third version of an analogous hue scheme, which calls for a small proportion of hue opposite to one of the analogous hues to be added to the piece for contrast. The scheme is similar to an unbalanced version of the horizontal cross-section score or the diagonal cross-section score discussed in Chapter 12, Color Combinations.

FIGURE 70
page 107

Opposite Hue Scheme or Dyads

A hue scheme based on two opposite hues, as discussed in Chapter 5, Opposite Hues. The hues in the scheme may be used in any range of values and chromas. The horizontal cross-section score and the diagonal cross-section score discussed in Chapter 12, Color Combinations, are examples of opposite hue schemes.

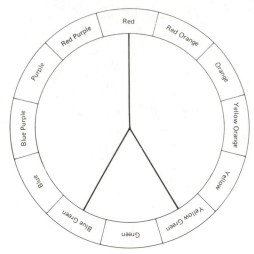

Diagram of Split Opposite Hues

Split Opposite Hue Scheme

A scheme of a contrast of opposite hues with three hues in which one hue is the key hue and the other hues are the hues on either side of the key hue's opposite.

For example:

Key hue: Red
 Blue-Green
 Yellow-Green

Warm and Cool Hue Scheme

A color scheme of the color effect of warm and cool hues, as discussed in Chapter 6, Warm and Cool Hues.

Triad Hue Scheme

A hue scheme of any three hues equidistant from each other which thereby form an equilateral triangle, in plain view, on a color circle.

For example:

Red
Yellow
Blue
or

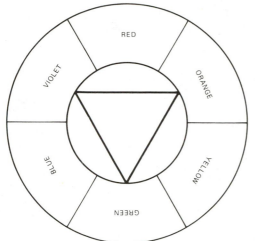

Diagram of Triad Hues

Green
Orange
Purple
or
Red-Orange
Yellow-Green
Blue-Purple

The hues in the scheme may be used in any range of values and chromas.

Discordant Hue Scheme

A contrast-of-hues scheme of any two or three hues not commonly associated with one another, this scheme must also have extreme contrast in value and/or chroma between the hues.

For example:

pure yellow and very light pink

Tetrads

A contrast of hues scheme of four or more hues equidistant from each other on a color circle. The scheme usually consists of two opposite hues and the two hues perpendicular to both on a color circle. The scheme is either square or rectangular, in plain view, on a color circle.

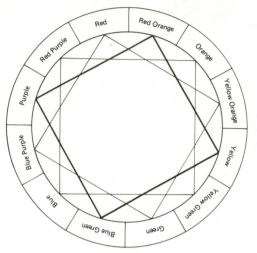

Diagram of Tetrads—Square Plan

FIGURE 71
page 107

Square-plan examples:

Red-Orange
Yellow
Blue-Green
Purple

Red
Yellow-Orange
Green
Blue-Purple

Orange
Yellow-Green
Blue
Red-Purple

FIGURE 72
page 107

Rectangular-plan examples:

Yellow-Orange
Yellow-Green
Blue-Purple
Red-Purple

Orange
Yellow
Blue
Purple

Red-Orange
Yellow-Green
Blue-Green
Red-Purple

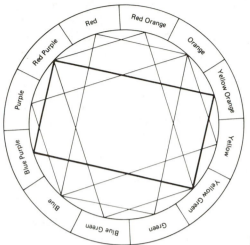

Diagram of Tetrads—Rectangular Plan

Red
Orange
Green
Blue

The hues in the scheme can be used in any range of values and chromas desired.

Polychromatic Hue Scheme

Polychromatic merely means many colors. These are, therefore, color schemes of several hues. These schemes are like the circular score, flat spiral score, helical score, and three-dimensional through psychological space score discussed in Chapter 12, Color Combinations.

High-Keyed Hue Scheme

A scheme of any number of hues, all of the same high values and intense chromas, with a dominant sense of white to the scheme.

Low-Keyed Hue Scheme

A scheme of any number of hues, all of the same very low values and weak chromas, with a dominant sense of darkness to the scheme.

In the Munsell System, color schemes are called color arrangements. There are **Eight Basic Color Arrangements** in the Munsell System. Each arrangement is designed to satisfy the four points necessary to any good color scheme.

A color scheme must:

1. Please the artist
2. Be appropriate to the purpose and form
3. Have variety and/or harmony
4. Possess recognizable unity

To be able to use the Eight Basic Color Arrangements of the Munsell System, you must understand the terms which follow.

Harmonious Hues

These are hue groups which are six steps or less apart from either side of a key hue or are only three steps away from a key hue on each side on the Munsell Color Circle.

Contrasting Hues

These are hue groups which are diametrically opposed or which have more than six steps between the key hue on the Munsell Color Circle.

Harmonious Values

These are values four steps or less apart on the Munsell Value Scale.

Contrasting Values

These are values more than four steps apart on the Munsell Value Scale.

Harmonious Chromas

These are chromas which all have the same degree of intensity, either weak, medium, or strong.

Contrasting Chromas

These are chromas which range in degree of intensity from weak to strong.

The Eight Basic Color Arrangements

1. Harmonious Hues
 Harmonious Values
 Harmonious Chromas

 FIGURE 73
 page 108

2. Harmonious Hues
 Harmonious Values
 Contrasting Chromas

 FIGURE 74
 page 108

3. Harmonious Hues
 Contrasting Values
 Harmonious Chromas

 FIGURE 75
 page 108

4. Harmonious Hues
 Contrasting Values
 Contrasting Chromas

 FIGURE 76
 page 108

5. Contrasting Hues
 Harmonious Values
 Harmonious Chromas

 FIGURE 77
 page 108

6. Contrasting Hues
 Harmonious Values
 Contrasting Chromas

 FIGURE 78
 page 108

7. Contrasting Hues
 Contrasting Values
 Harmonious Chromas

 FIGURE 79
 page 108

8. Contrasting Hues
 Contrasting Values
 Contrasting Chromas

 FIGURE 80
 page 108

The Munsell color arrangements are not as complex when used as the system first appears. For example, if you desire a very harmonious color scheme with just a slight sense of contrast, you would select either arrangement number two or number three for the effect. Each arrangement has specific characteristics and should be used when the sense of the color combination to be produced is known.

All of these color schemes are only suggestions for a plan for a color combination problem. A color scheme can be followed exactly as outlined or altered to fit specific needs, with changes in the relations of factors such as proportions, values, chromas, and the color effects.

PROBLEM 38

Cut fifteen four-by-four-inch white smooth-surfaced mat boards, and very lightly pencil a one-inch square grid on each board.

Use any number of types of color agents to complete a four-color design of four one-by-four-inch stripes which demonstrate each of the fifteen color schemes discussed in this section of the manual. Each scheme should be constructed on a separate board.

Display the finished boards so the exercises can be seen often, and **review** the results in relation to the effects of each color scheme discussed in this section of the manual.

PROBLEM 39

Select one colored photograph from the colored photograph collection of Problem 2 which best represents each of the Eight Basic Color Arrangements.

Display the photographs so the exercise can be seen often, and **review** the results in relation to the effect of the Munsell color arrangements discussed in this section of the manual.

14 PERSONAL PSYCHOLOGICAL COLOR ASSOCIATIONS

The psychology of coloration has taken two different directions.

One direction is based on the assumption that psychological associations with color can be standardized through the results of mass tests.

The other direction is based on the discovery of individual psychological associations with color. The personal, associative direction has as much merit as any other color concept, especially when used in conjunction with the knowledge of the color effects. Many valuable inferences can be drawn from subjective color preferences.

Kandinsky advises one to study the color effects and record the personal associations with each color. Here is an excerpt from his book, *Concerning the Spiritual in Art*:*

- The unbounded warmth of red has not the irresponsible appeal of yellow, but rings inwardly with a determined and powerful intensity. It glows in itself, maturely, and does not distribute its vigour aimlessly.
- The varied powers of red are very striking. By a skillful use of it in its different shades, its fundamental tone may be made warm or cold.
- Light warm red has a certain similarity to medium yellow, alike in texture and appeal, and gives a feeling of strength, vigour, determination, triumph. In music, it is a sound of trumpets, strong, harsh, and ringing.
- Vermilion is a red with a feeling of sharpness, like glowing steel which can be cooled by water. Vermilion is quenched by blue, for it can support no mixture with a cold colour. More accurately speaking, such a mixture produces what is called a dirty colour, scorned by painters of today. But "dirt" as a material object has its own inner appeal, and therefore to avoid it in painting, is as unjust and narrow as was the cry of yesterday for pure colour. At the call of the inner need that which is outwardly foul may be inwardly pure, and vice versa.
- The two shades of red just discussed are similar to yellow except that they reach out less to the spectator. The glow of red is within itself. For this reason it is a

*New York, Dover Publications, Inc., 1977. Reprinted by permission.

colour more beloved than yellow, being frequently used in primitive and traditional decoration, and also in peasant costumes, because in the open air the harmony of red and green is very beautiful. Taken by itself this red is material, and, like yellow, has no very deep appeal. Only when combined with something nobler does it acquire this deep appeal. It is dangerous to seek to deepen red by an admixture of black, for black quenches the glow, or at least reduces it considerably.

• But there remains brown, unemotional, disinclined for movement. An intermixture of red is outwardly barely audible, but there rings out a powerful inner harmony. Skillful blending can produce an inner appeal of extraordinary, indescribable beauty. The vermilion now rings like a great trumpet, or thunders like a drum.

• Cool red (madder) like any other fundamentally cold colour, can be deepened—especially by an intermixture of azure. The character of the colour changes; the inward glow increases, the active element gradually disappears. But this active element is never so wholly absent as in deep green. There always remains a hint of renewed vigour, somewhere out of sight, waiting for a certain moment to burst forth afresh. In this lies the great difference between a deepened red and a deepened blue, because in red there is always a trace of the material. A parallel in music are the sad, middle tones of a cello. A cold, light red contains a very distinct bodily or material element, but it is always pure, like the fresh beauty of the face of a young girl. The singing notes of a violin express this exactly in music.

• Warm red, intensified by a suitable yellow, is orange. This blend brings red almost to the point of spreading out towards the spectator. But the element of red is always sufficiently strong to keep the colour from flippancy. Orange is like a man, convinced of his own powers. Its note is that of the angelus, or of an old violin.

• Violet is therefore both in the physical and spiritual sense a cooled red. It is consequently rather sad and ailing. It is worn by old women, and in China as a sign of mourning. In music it is an English horn, or the deep notes of wood instruments (e.g. a bassoon).

Your personal associations with colors can be as simple or as complex as necessary for your use.

Color associations can come from many sources, such as childhood memories, recent memories, purely emotional responses, and synesthetic reactions. You should be able to find associations with such factors as tastes, sounds, temperature, touch and texture, smell, and weight; possibly even with such concepts as geographical locales, months of the year, philosophical concepts; and anything else which comes to mind when you see a certain color.

All of the hues, even at the different values and chromas, can symbolize something to you when you consider the color for a moment. The more you can think about colors in a symbolic manner, the easier colors will be to work with.

All of your associations for each specific hue should be recorded in writing and used in relationship with the color effects. At first the associations might seem forced, but with practice you will be able to form your own personal concepts of colors you work with.

If you wish to go further to understand your personal associations, Johannes Itten suggests you also make personal associations with color combinations.

PROBLEM 40

Record your personal associations with each of the ten basic hues and black, white, and gray. Write out your personal associations on separate pieces of paper based on the guidelines discussed in this section of the manual.

PROBLEM 41

Cut an eight-by-eight-inch square smooth-surfaced white mat board, and lightly pencil a one-inch square grid over the entire board.

Use any type of color agent and any number of colors. Create an analytical design of sixty-four squares which depicts specific concepts or emotions. Use only the colors for the symbols. Use your record of personal psychological color associations and your color circle to make your color decisions.

Display the finished board so the exercise can be seen often, and review the results in relation to your personal psychological color association records discussed in this section of the manual.

UNIVERSAL PSYCHOLOGICAL COLOR ASSOCIATIONS 15

This section of the manual will give the data which have been collected on the Universal Psychological Associations or the ethico-aesthetic values associated with the ten basic hues and black, white, and gray.

The universal associations will be listed under the categories which follow.

General Associations

This list will include the conceptual associations most often made with the color.

General Symbolism

This list will give some of the color associations of ancient cultures. In each case the culture will be identified with the associations. Remember that some of these seemingly mystical associations still have a strong influence on the universal color associations of today.

Sensory Associations

This list will indicate the universal associations of color to such factors as taste, smell, food, appetite, and weight.

Preference Ratings

This list will give the statistical results of the universal favorite colors of adults, children, and the elderly.

Visibility Ratings

This list will give the statistical results of such factors as color visibility, attention/attraction ability, and legibility of color combinations for letter forms.

Color to Shape Relationships

This list will give the most universally appropriate shapes or forms for each color.

Visual Motion

This list will give the universal associations of motion and direction for each color.

Environmental Uses

This list will suggest the best use of each color in such environments as industry, the home, and other places where applicable.

Miscellaneous

This list will consist of data on universal associations which do not relate to the other categories.

In all cases, the rating of one is the highest. For example, for the hue red, the weight rating is two, which means red appears to be the second most heavy color after number one, black.

Universal associations of tints and shades of each hue are given where the data are available.

Equal amounts of data have not been collected on each hue. Some hues lack entries in some categories.

The material on the universal psychological color associations is not necessarily factual, but is given only as suggestions for a more complete general reference to color.

RED

General Associations

Strength, virility, masculinity, dynamism, brutal, exalting, imposing, dignity, benevolence, charm, warm, overflowing, ardent, power, not dissipating, irresistible, attracts at a glance, we look at it even if we do not want to, hot, dry, opaque, equilibrium, exciting, restless, tension, extroverted, saints, sinners, patriots, anarchists, love, hate, compassion, war, counteracts melancholia, paint-the-town red, see red in anger, falling profits, red herring, red-letter day, redheads, redcaps, red cent, comedy, vigor, severe, traditional, rich, active, solid, sensual, erotic, triumph, Mars.

Jungian: blood, fire, surging and tearing emotion.

General Symbolism

Ancient Medicine: good for melancholia, respiration, sunburn, male sex glands, wounds, stimulates blood and bleeding, thwarts smallpox and scarlet fever, convulsions, sore throats, sprains and nightmares. Protects against fire and lightning, prolongs life.

Primitive Man: the body.

Egypt: man, sun, Shu.

Greece: Ceres, sacrifice to love, blood, and fire.

India: Mother Goddess, evil.

Zuñis: fire.

Heraldry: Gules, courage and zeal.

Christianity: Holy Ghost, medieval sun, the body, charity, and martyrdom.

da Vinci: fire.

American University: theology.

Sensory Associations

Taste: sweet.

Smell: perfumed.

Food: caffeine.

Appetite rating: 2

Smell rating: 1

Weight rating: 2

Preference Ratings

Adults: 2

Children: 3

In combination with blue: 1

In combination with green: 3

In combination with yellow: 6

Favored by people in sunny climates, the "masses," maniacs, some color-blind people, and country dwellers.

Visibility Ratings

Daylight: 1
Night: 6
Attention/Attraction: 2
Legibility in combination ratings:
 Red on White: 4
 Red on Yellow: 12
 Black on Red: 16
 Blue on Red: 29
 Yellow on Red: 20
 White on Red: 21
 Red on Black: 22
 Red on Orange: 28
 Red on Green: 29

Color to Shape Relationship

Best shapes are squares, cubes, right angles, and structural planes.

Visual Motion

Expansion, eccentric.

Environmental Uses

Industrial: exclusive for fire protection.

Miscellaneous

Not attractive to bugs, strong influence on plants, quickens human muscle response, the letter *E,* Aries, Scorpio, Independence Day, Christmas.

Light Valued Red: Pink

Animated, energetic, joyful, beautiful, expressive, emotional, shy, sweet, romantic, feminine, gentle, affectionate, intimate, active.

American University: music.
Preferred with white or in tints.
Summer color.
Preference rating, children: 2
Favored by high-income groups, town dwellers.
Sweetish, thick, creamy liquid.
Hot pink favored by Third World countries.
Good bathroom color.

Dark Valued Red

Serious, problematic, importance, passive, in music *F*.
Preferred with shades and black.
Winter color.
Preferred by high-income groups.
Adult flavors.
Good floor color.

ORANGE

General Associations

Radiation, communication, whole-hearted, receptive, warm, intimate, like fire in a fireplace, comedy, pride, ambition, joy, happy, dynamic, cheerful, lively, exciting, brass instruments, autumn.
Jungian: fire and flames.

General Symbolism

Ancient Medicine: laxative, stimulates blood pressure, slightly enlivens emotions.
Zuñis: fire.
Hindus and Buddhists: sacred color.
Heraldry: Tenne, strength and endurance.
American University: engineering.

Sensory Associations

Taste: orange flavored, thirst.
Smell: peppery.
Appetite rating: 1

Preference Ratings

Adults: 5
Children: 4
Slightly favored in sunny climates, favored by low-income groups.

Visibility Ratings

Daylight: 2
Night: 5
Attention/Attraction rating 1
Legibility in combination ratings:
 Black on Orange: 11

Orange on Blue: 13
Blue on Orange: 17
White on Orange: 23
Orange on White: 25
Orange on Blue: 25
Yellow on Orange: 27
Red on Orange: 28
Green on Orange: 30

Color to Shape Relationship

Best shapes are trapezoids, rectangles, sharp images, and fine detail.

Visual Motion

Expansion, eccentric.

Environmental Uses

Industrial: acute hazards that are likely to cut, crush, burn, or shock such as switch boxes and cutting blades.

Miscellaneous

Not attractive to bugs. Used for Halloween, Thanksgiving Day.

Light Valued Orange: Peach

Mellow, livable, cheerful.
Summer color.
Appetite Rating: 3
Favored by high-income groups, town dwellers.
Good for large vaulted spaces, almost all interiors, sickrooms, active and cool spaces, bedrooms, and baths.

Dark Valued Orange

Most exciting, passive.
Appetite rating: 9
Preferred with black and shades.
Winter color.
Favored by high-income groups.
Adult flavors.
Good color for floors and walls facing workers.

YELLOW

General Associations

Magnanimity, intuition, intellect, loudest, most luminous, brightest, young, vivacious, extrovert, comedy, celestial, lacks weight and substance, favorable, biological, safety, scoundrel, coward, caution, yellow journalism, warmth, joy, sickness, dense, deceit, treachery, house of traitors and criminals, yellow-dog, yellow streak, spontaneity, active, projective, aspiring, investigatory, original, expectant, varied, exhilaration, spring, summer.

Jungian: flash of illumination, sun, dissemination.

General Symbolism

Ancient Medicine: laxative, emetic, good for bronchial tubes, hemorrhoids, mental stimulation, headaches, procuring sleep, jaundice, protects against the plague.

Primitive Man: the mind.

Egypt: the sun, Ra.

Greece: air, Athena.

India: Buddhists' most-honored color.

Zuñis: air.

Heraldry: Or, gold, honor and loyalty.

Christianity: Son of God, confessor; the mind, Judas color.

da Vinci: earth.

China: Confucius, royal, wrath, and sun.

American University: science.

Sensory Associations

Taste: sweet, lemon.

Food: powdery, black and yellow for insecticides.

Appetite Rating: 5

Weight Rating: 7

Preference Ratings:

Adults: 6

Children: 1

In combination with blue: 4

In combination with green: 5

In combination with red: 6

Least-favorite color of most cultures, favored in sunny climates, favored by country dwellers, schizophrenics, in fashion from 1890–1900, favored by Pre-Raphaelites.

In America: weak, not tactile, cheap.

Visibility Ratings:

Daylight: 3
Night: 4
Attention/Attraction: 6
Legibility in combination ratings:
 Black on Yellow: 1
 Yellow on Black: 2
 Blue on Yellow: 7
 Green on Yellow: 10
 Red on Yellow: 12
 Yellow on Blue: 14
 Yellow on Green: 18
 Yellow on Red: 20
 Yellow on Orange: 27

Color to Shape Relationship

Best shapes are triangles, inverted triangles, pyramids, aggressive angles, pointed sharp forms.

Visual Motion

Expansion, eccentric.

Environmental Uses

Industrial: yellow with black bands means hazards. Good for stairwells, basements, rooms with little light.

Miscellaneous

Not attractive to bugs, neutral effect on plants, with blue no depth, with red conquering, elderly people dislike yellow, bad luck to have yellow in theater, posters, Leo, best protection for light-sensitive chemicals, Easter.

Light Valued Yellow

Extrovert, good smell.
Appetite Rating: 7
Chilly spaces, large spaces.
The letter *I*.

Dark Valued Yellow: Ochre

Active, appetizing, thirst.
Jungian: earth.
Appetite Rating: 4
The letter *Y*.

YELLOW-GREEN

General Associations
Strength, sunlight, biology, most tranquilizing, sickly.

Sensory Associations
Taste: acid.
Food: worst associations.

Preference Ratings
Adults: very low.

Environmental Uses
Not to be used near sick people, casts unfavorable light on complexions.

Miscellaneous:
Neutral effect on plants.

GREEN

General Associations
Sympathy, adaptability, hope, quietest color, no direction, no expression, middle of the road, undemanding, soft, not angular, pacific, not nervous, not muscular, tranquil, thinking, concentration, mediation, jealousy, cool, fresh, inexperienced worker, greenhorns, abundance, health, hope of new life, oboe, Venus, verdure, fecundity, fertile growth, sea, fields, greenbacks.
Jungian: earth, tangible, immediate, growth, vegetation, death.

General Symbolism
Ancient Medicine: lowers blood pressure, sedative, treats irritability, exhaustion, headaches, fears, reduces muscle and nerve tension.
Egypt: nature, Osiris, eternity, scarab of death.
Greece: water.
Zuñis: water.
Heraldry: Vert, youth and fertility.
Christianity: faith, immortality, contemplation.
da Vinci: water.
China: Ming Dynasty.
Islam: sacred color.
American University: medicine.

Sensory Associations

Smell: slightly spicy, pine.
Food: frozen vegetables.
Appetite rating: 6
Smell rating: 3
Weight rating: 6

Preference Ratings

Adults: 3
Children: 6
In combination with blue: 2
In combination with red: 3
In combination with yellow: 5
Second favorite color of the insane, especially hysterical patients. Less favored in sunny climates, least favorite of country dwellers.
In America: rather serious, with red and blue interesting.

Visibility Ratings

Daylight: 4—produces least eye strain.
Night: 3.
Attention/Attraction: 5—most easily forgotten.
Legibility in combination ratings:
 Green on White: 3
 Green on Yellow: 10
 White on Green: 15
 Yellow on Green: 18
 Black on Green: 24
 Red on Green: 29
 Green on Orange: 30

Color to Shape Relationship

Best for rounded triangles, hexagons.

Visual Motion

Neutral, appears larger than self.

Environmental Uses

Industrial: first aid, critical task areas, sedentary tasks, areas of concentration or mediation, surgery because of less glare and complementary to blood and tissue.

Miscellaneous:

Neutral to plants, induces need for rest, retards muscle response, causes confessions, Libra, St. Patrick's Day, Christmas.

Light Valued Green

Sympathy, compassion.
Early Christianity: baptism.
Taste: salty.
Appetite Rating: 8

Dark Valued Green

Versatility, ingenuity, naturalness, healthiness.
Taurus.

BLUE-GREEN

General Associations

Serious, pensive, lively, mellow, cheerful, clarity, certainty, firm, consistent, great strength, inner coldness, lakes, flattering, reliable, incorruptible.

General Symbolism

Medicine: protects against the evil eye.

Sensory Associations

Food: thirst.

Preference Ratings

Favored by town dwellers.

Visibility Ratings

Night: highest.

Color to Shape Relationship

Liquids.

Environmental Uses

Good near skin, surgery, secondary schools.

Miscellaneous

Pisces

BLUE

General Associations

Vertical, height, depth, levels, upward, deep, feminine, relaxed, mature, recalls childhood, inner life, seized by love, not violent, quiet, cold, wet, repose, feeling blue, the blues, insane, mental depression, blue Monday, blue bloods, once in a blue moon, bolt from the blue, flute, stringed instruments, Mercury, clear, cool, transparent, introspective, recessive, distant, summer, water, mournful.

Jungian: thinking.

General Symbolism

Ancient Medicine: good for headaches, sunstroke, nervousness, contracts arteries, raises blood pressure, stimulates pituitary gland, stops baldness.

Primitive Man: the spirit.

Egypt: Amen, truth.

Greece: altruism, integrity, earth, truth.

Heraldry: Azure, piety and sincerity.

Christianity: God, the Lord's color, the throne, spirit, hope, divine works.

da Vinci: air.

China: emperor, sky.

Hebrews: hue of Jehovah.

American University: philosophy.

Sensory Associations

Taste: sweet.

Food: sugar, eggs, soap, butter.

Appetite rating: 10

Weight rating: 5

Preference Ratings

Adults: 1

Children: 5

In combination with red: 1

In combination with green: 2

In combination with yellow: 4

Favored by the elderly, the insane, and intellectuals, less-favored in sunny climates.

In America: modern, young, fairly warm, with red and green interesting.

Visibility Ratings

Daylight: 5
Night: 2
Attention/Attraction: 3

Legibility in Combination Ratings:

White on Blue: 6
Blue on Yellow: 7
Blue on White: 8
Yellow on Blue: 14
Blue on Orange: 17
Orange on Blue: 25
Blue on Red: 29

Color to Shape Relationship

Best shapes are circles, spheres, rounded angles.

Visual Motion

Concentric, solid, compact, appears slightly larger than self.

Environmental Uses

Industrial: caution signals, warm rooms, men's bathrooms, critical task areas, not suitable for public spaces.

Miscellaneous

Retards the growth of plants, induces need for rest, attracts bugs, Sagittarius.

Light Valued Blue

Glory, good, indifferent, empty, refreshing, hygienic, clean, devotion to noble ideas, blurry, pleasure, peace.
Jungian: sky, calm, sea.

Valentine's Day with red.

Dark Valued Blue: Navy

Gloom, devotion, security, solemnity, gravity, irrationality, great religious feelings.
Jungian: sky, night, stormy sea.
Preferred by high-income groups.
Bad visibility in dim light.

PURPLE-BLUE

General Association
Tragedy

Sensory Associations
Taste: sweet.
Smell: mold.
Appetite Rating: very low.

Visibility Ratings
Daylight: 6
Night: 1

PURPLE

General Associations
Nostalgia, memories, power, spirituality, sublimation, melancholia, meditative, mystical, thought, dignified, subducing, aesthetic, clings to the earth, important, celibacy, rage, priggishness.

General Symbolism
Ancient Medicine: stimulates heart, lungs, blood vessels, female sex glands, thwarts adversity.
Egypt: earth.
Greece: sea.
Rome: imperial, Jupiter.
Zuñis: water.
Heraldry: Purpure, royalty and rank.
Christianity: suffering, individual, penitent.
American University: law

Sensory Associations
Taste: bitter.
Appetite Rating: 11
Weight Rating: 84

Preference Ratings
Adults: 4
Children: 7

Visibility Ratings
Attention/Attraction: 7

Color to Shape Relationship
Best shapes are ellipses, ovals, flowing forms.

Environmental Uses
Not good for public spaces or sick rooms.

Miscellaneous
The letter *U*.

Light Valued Purple: Lavender
Smell rating: 2
Smell: perfumed.
Appetite rating: good for sweets.

RED-PURPLE

General Symbolism
Medicine: prolongs life.

Sensory Associations
Smell: perfumed.
Food: candy, with yellow for insecticides.

Miscellaneous
Mother's Day.

BLACK

General Associations
Dark, compact, death, despair, impenetrable, void, eternal silence, no future, rigid, without peculiarity, distant, noble, elegant, negative, evil, blackmail, blackball, blacklist, gloom, hatred, malice, anger, fear, blindness, black magic, piano, winter, percussion instruments, black cats.
Jungian: fertile land.

General Symbolism

Ancient Medicine: restores hair color.
Egypt: Set.
India: Siva.
Zuñis: earth.
Middle Ages: darkness, beginning.
Heraldry: Sable, grief and penitence.
Christianity: death, regeneration, silence.

Sensory Associations

Smell: bad smelling.
Weight rating: 1

Preference Ratings

In combination with shades: better.

Visibility Ratings

Daylight: 4
Night: lowest, best black on white.

Legibility in combination ratings:

Black on Yellow: 1
Yellow on Black: 2
Black on White: 5
White on Black: 9
Black on Orange: 11
Orange on Black: 13
Black on Red: 16
Red on Black: 22
Black on Green: 24

Visual Motion

Concentric.

Environmental Uses

Industrial: traffic signals with white and gray.

Miscellaneous

The letter *O,* Capricorn, with white for New Year's Day.

WHITE

General Associations

Purity, inaccessible, inexplicable, emptiness, silence, infinity, refreshing, antiseptic, perfect balance, zest, awareness, pleasure, cold, clean, percussion instruments.

General Symbolism

Egypt: Horus.
Greece: purity.
Middle Ages: light of creation.
Heraldry: faith and purity.
Christianity: chastity, innocence, purity.
China: mourning.
Japan: death.
American University: arts and letters.

Sensory Associations

Weight Rating: 8

Preference Ratings

In combination with tints: better.
Favored by town dwellers.

Visibility Ratings

Legibility in combination ratings:
 Green on White: 3
 Red on White: 4
 Black on White: 5
 White on Blue: 6
 Blue on White: 8
 White on Black: 9
 White on Green: 15
 White on Red: 21
 White on Orange: 23

Visual Motion

Eccentric, appears much larger than self.

Environmental Uses

Industrial: traffic signals with black and gray, good for high ceilings and window shades.

Miscellaneous

The letter *A*, looks largest, with black for New Year's Day.

GRAY

General Associations

Egoism, depression, inertia, indifference, ashes, autonomous, nothing, neutral, indecision, lack of energy, passion, old age, tragedy, selfishness, deceit, cunning, percussion instruments.

Sensory Associations

Taste: salty.
Smell: disagreeable odors.
Smell rating: low.
Weight rating: 3

Preference Ratings

Favored by town dwellers and people in cold climates.

Visibility Ratings

Attention/Attraction: 8

Visual Motion

Neutral.

Environmental Uses

Industrial: traffic signals with black and white.

Miscellaneous

The letter *Y*, Cancer, and Aquarius.

Light Valued Gray

Fear, old age, coming death.
Bedrooms.

Dark Valued Gray

Color of dirt.

COLOR INDEX

3 THE THREE ATTRIBUTES OF COLOR

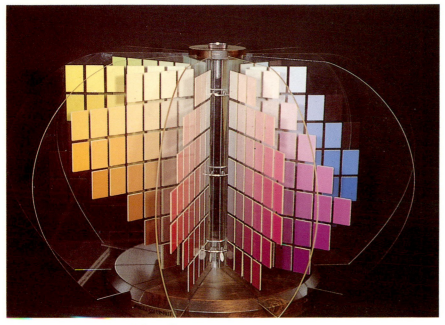

FIGURE 1 The Munsell Color Tree

FIGURE 2
Munsell Red Hue Chart

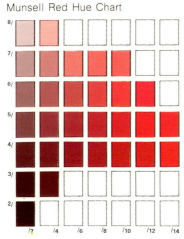

FIGURE 3
Yellow-Red Hue Chart

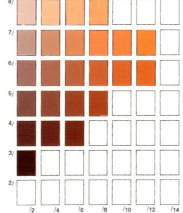

FIGURE 4
Red-Yellow-Red Hue Chart

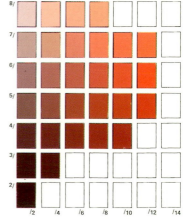

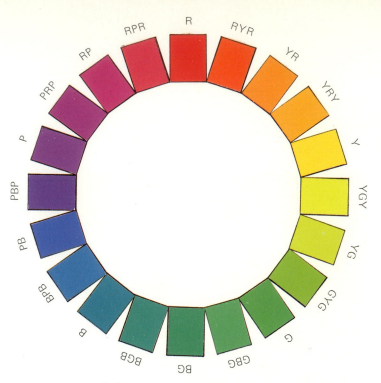

FIGURE 5 Munsell Color Circle

FIGURE 7 Munsell Value Chart Compared to the Munsell 5.0 Red Hue Chart

FIGURE 6 Munsell Value Chart

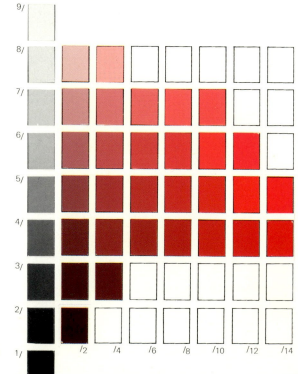

94

4

PRIMARY HUES

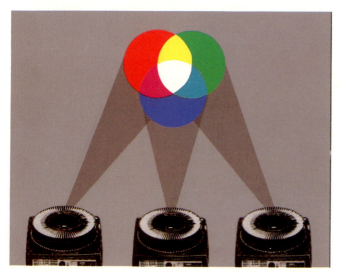

FIGURE 8 Diagram of Three Projectors Producing the Additive
System of Primary Hues

FIGURE 9 Jim Claussen, *Home of Bummen*

FIGURE 10 Diagram of Red, Yellow, and Blue

FIGURE 11 Diagram of Red, Yellow, and Blue with Black

FIGURE 12 Diagram of Red, Yellow, and Blue with White

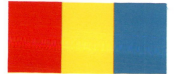

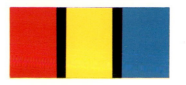

FIGURE 13
Sue Coe, *Final Problem—
Sherlock Confronts Moriarity*

FIGURE 14
Tom Lehn, *Interior Design*

FIGURE 16 Jacob Lawrence, *House Chores*

FIGURE 15 Reginald Marsh, *1120 South Street*

FIGURE 17 William Morris, *Evenlode*

5

OPPOSITE HUES

FIGURE 18
Black, White, and Gray

FIGURE 19
Blue, Gray, and Orange

FIGURE 21
Douglas Jasso, *Mexican Girl
as Cat Women*

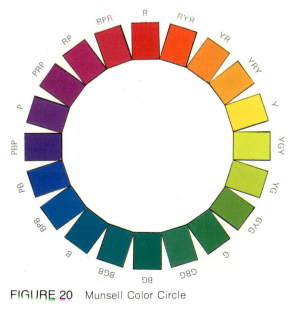

FIGURE 20 Munsell Color Circle

FIGURE 22
Lonn C. A. Beaudry, Design Michigan Poster/Mailer

WARM AND COOL HUES

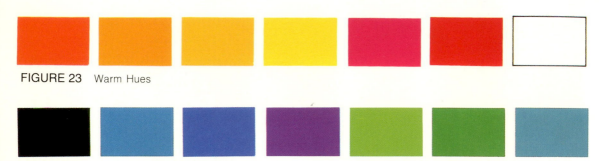

FIGURE 23 Warm Hues

FIGURE 24 Cool Hues

FIGURE 25
Yellow-Green and Blue

FIGURE 27 Jane Lackey, Untitled Diptyche 1977

FIGURE 26
Light Blue and Dark Red

FIGURE 28 V. Marshall,
Costume Design for *Kismet*

FIGURE 29 Otagawa Kuniyoshi,
Famous Views of Eastern Capital

7 AFTERIMAGE AND THE SIMULTANEOUS CONTRAST OF HUES

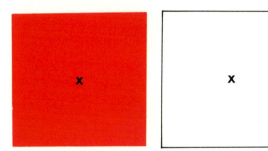
FIGURE 30 Diagram of Afterimage

FIGURE 33 Majolica Plate

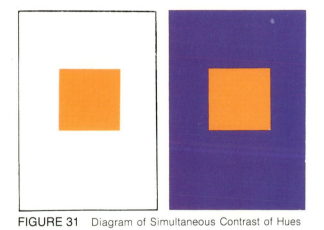
FIGURE 31 Diagram of Simultaneous Contrast of Hues

FIGURE 32 Diagram of Simultaneous Contrast

FIGURE 34
Diagram of Simultaneous Contrast of Value

FIGURE 35
Diagram of Simultaneous Contrast of Chroma

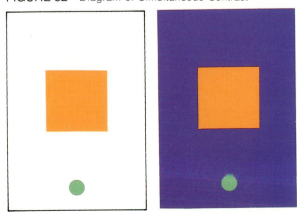

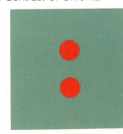

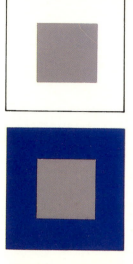

FIGURE 36

Diagram of Simultaneous
Contrast of Gray

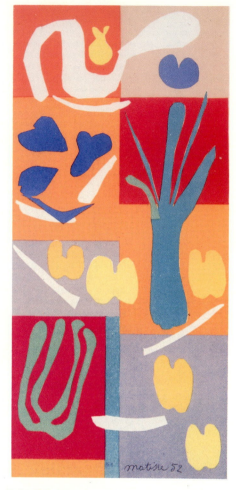

FIGURE 38

Paul Cézanne, *La Montagne St. Victoire*

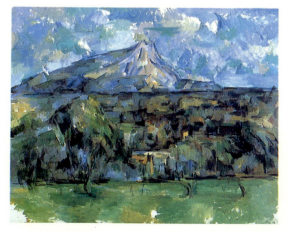

FIGURE 37 Henri Matisse, *Vegates*

FIGURE 39 Joanne Nettzle, *Color Exercise*

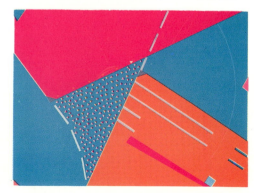

8

VALUES OF HUES

9/

8/

7/

6/

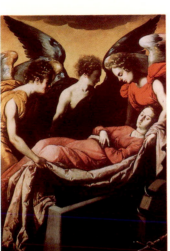

FIGURE 41
Francisco de Zurbarán,
The Entombment of St. Catherine

5/

4/

3/

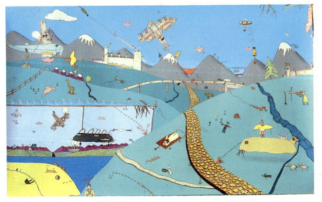

FIGURE 42 Dan Younger, *View From My Studio*

2/

1/

FIGURE 40
Munsell Value Chart

FIGURE 43
Yellow and Purple

9

CHROMAS OF HUES

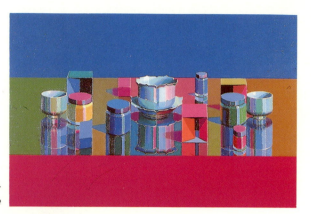

FIGURE 44
Ronald Christ, *Still Life*

FIGURE 45
Circle of George de La Tour,
St. Sebastian Nursed by St. Irene

FIGURE 46
Wassily Kandinsky,
Rosa Mit Gran 1924

10

PROPORTIONS OF HUES

8

6

FIGURE 48

Munsell 5.0 Yellow $8/12$
and 5.0 Purple Blue $5/10$
Color Chips

3

4

FIGURE 49

Munsell 5.0 Yellow $8/12$ and 5.0 Purple Blue $5/10$ in Proportions

6

FIGURE 47

Goethe's Harmonious Scale of Areas

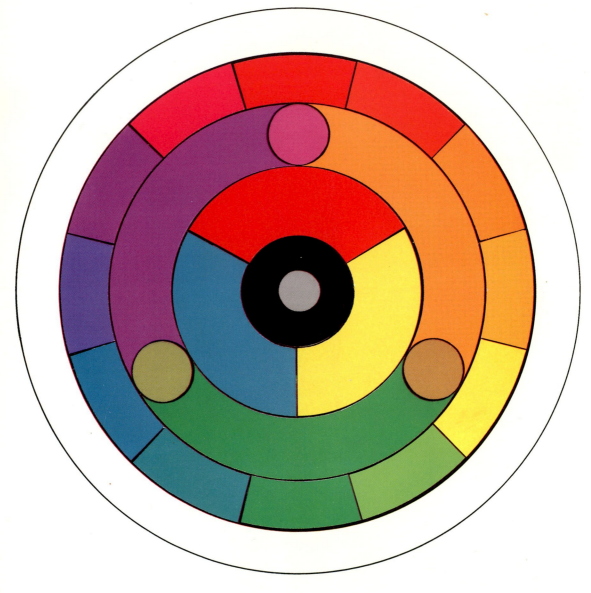

FIGURE 50 Manual Color Circle

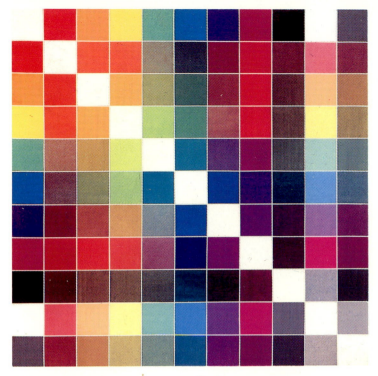

FIGURE 51 Intermixtures of Hues Chart

FIGURE 52
Green and Green with Yellow

FIGURE 53
Green and Green with Blue

FIGURE 54
Green and Green with White

FIGURE 55
Green and Green with Black

FIGURE 56
Green and Green with Gray

FIGURE 57
Green and Green with Red

FIGURE 58
Yellow and Magenta
with Intermixture

FIGURE 59
Browns

FIGURE 60
Bluish-Orangish-Pink
and Red-Green-Black

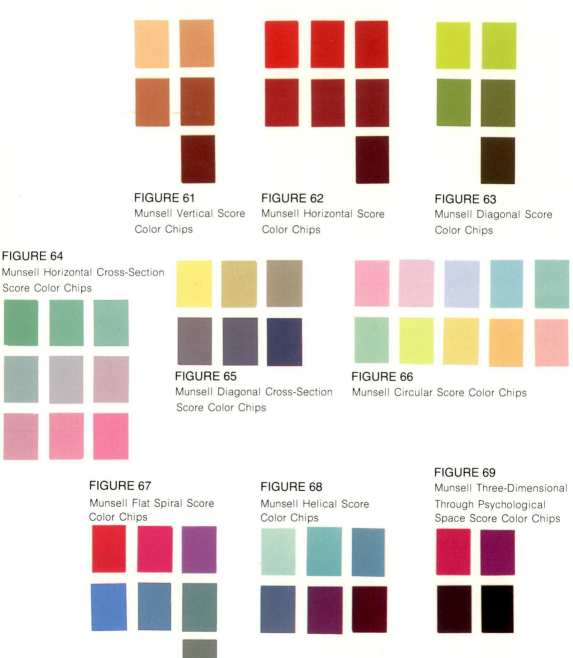

FIGURE 61
Munsell Vertical Score
Color Chips

FIGURE 62
Munsell Horizontal Score
Color Chips

FIGURE 63
Munsell Diagonal Score
Color Chips

FIGURE 64
Munsell Horizontal Cross-Section
Score Color Chips

FIGURE 65
Munsell Diagonal Cross-Section
Score Color Chips

FIGURE 66
Munsell Circular Score Color Chips

FIGURE 67
Munsell Flat Spiral Score
Color Chips

FIGURE 68
Munsell Helical Score
Color Chips

FIGURE 69
Munsell Three-Dimensional
Through Psychological
Space Score Color Chips

13
COLOR SCHEMES

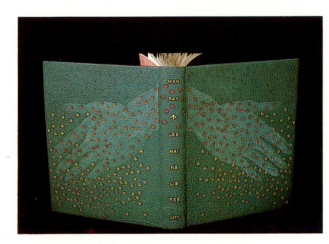

FIGURE 70
Gerard Charrier, *Les Mains Libres*—
Man Ray Book Binding

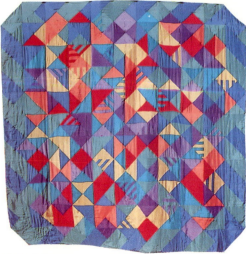

FIGURE 71 Julie Roach-Berner, *Quilt*

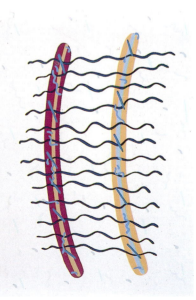

FIGURE 72 Olephan Cidolinger, *Sistrum*

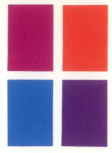

FIGURE 73
Munsell Color Arrangement 1

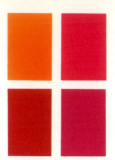

FIGURE 74
Munsell Color Arrangement 2

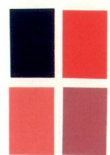

FIGURE 75
Munsell Color Arrangement 3

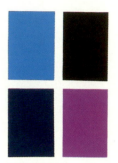

FIGURE 76
Munsell Color Arrangement 4

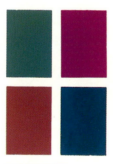

FIGURE 77
Munsell Color Arrangement 5

FIGURE 78
Munsell Color Arrangement 6

FIGURE 79
Munsell Color Arrangement 7

FIGURE 80
Munsell Color Arrangement 8

MUNSELL 5.0 RED HUE CHART

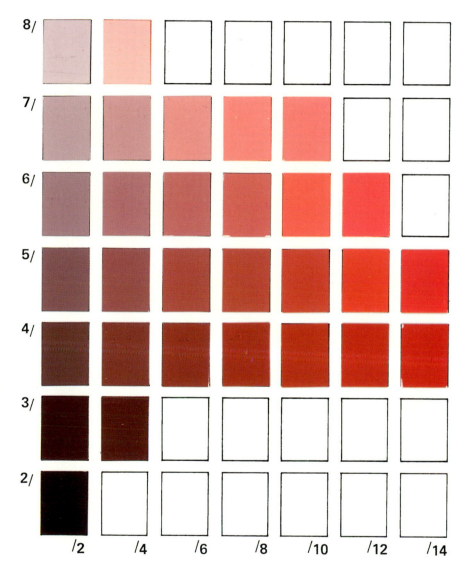

MUNSELL 5.0 YELLOW-RED HUE CHART

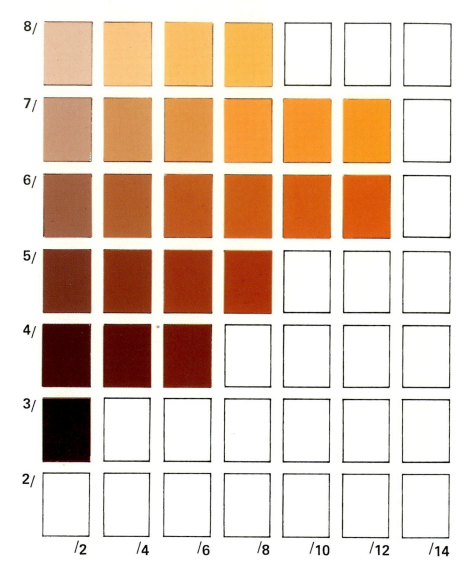

MUNSELL 5.0 YELLOW HUE CHART

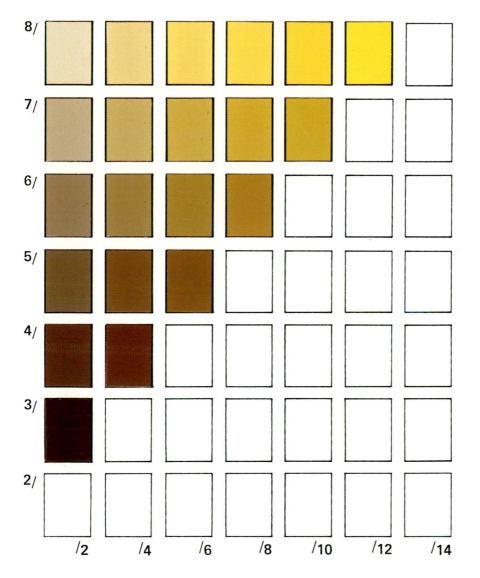

MUNSELL 5.0 YELLOW-GREEN HUE CHART

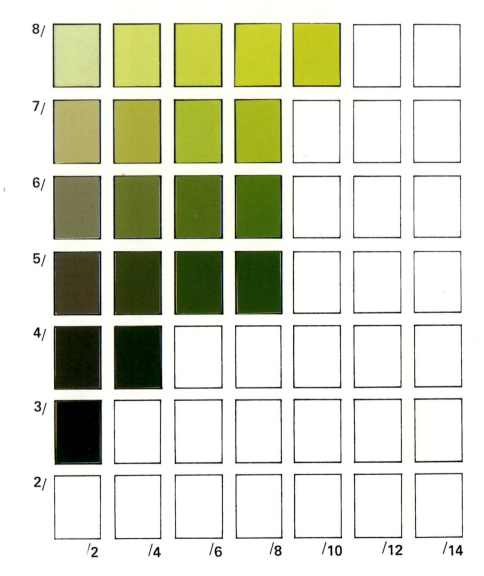

MUNSELL 5.0 GREEN HUE CHART

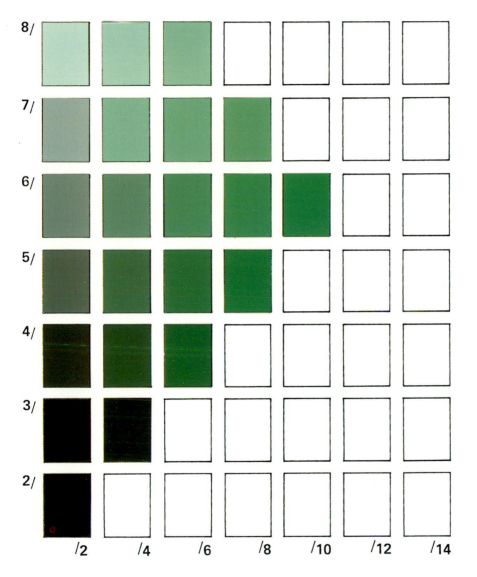

8/

7/

6/

5/

4/

3/

2/

/2 /4 /6 /8 /10 /12 /14

MUNSELL 5.0 BLUE-GREEN HUE CHART

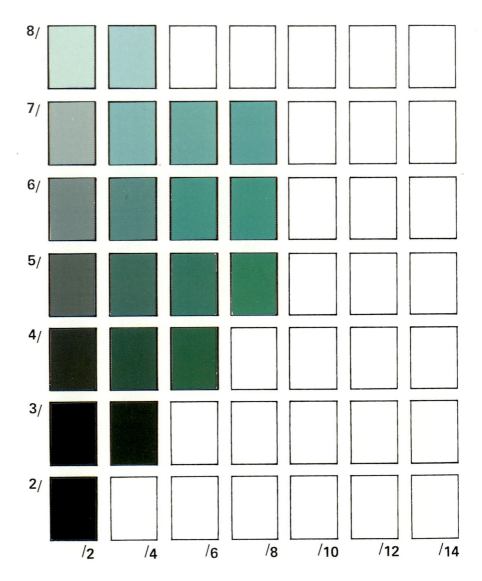

8/
7/
6/
5/
4/
3/
2/

/2 /4 /6 /8 /10 /12 /14

MUNSELL 5.0 BLUE HUE CHART

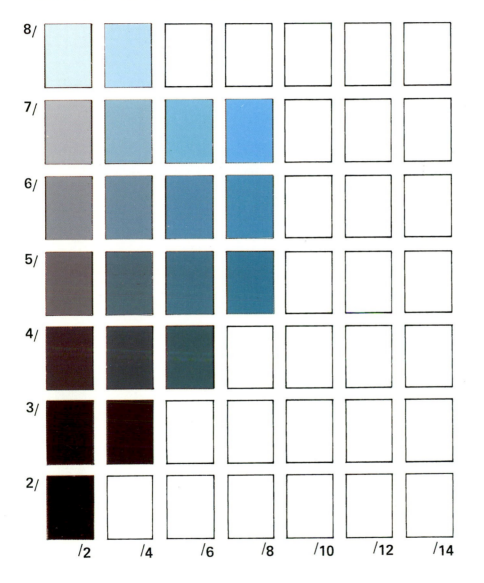

MUNSELL 5.0 BLUE-PURPLE HUE CHART

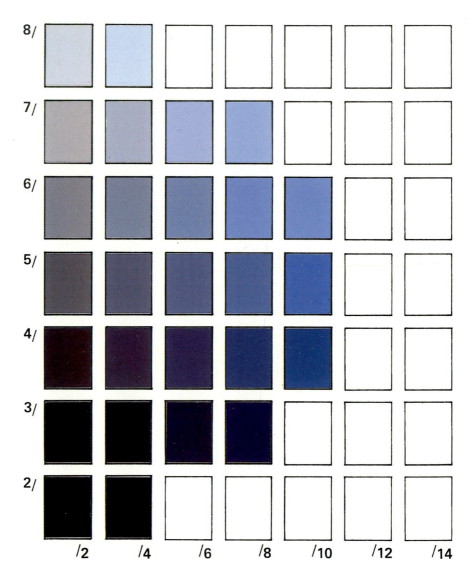

8/

7/

6/

5/

4/

3/

2/

/2 /4 /6 /8 /10 /12 /14

MUNSELL 5.0 PURPLE HUE CHART

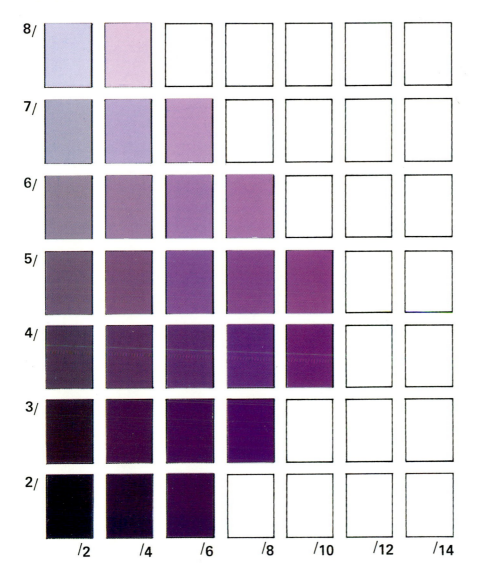

8/

7/

6/

5/

4/

3/

2/

/2 /4 /6 /8 /10 /12 /14

MUNSELL 5.0 RED-PURPLE HUE CHART

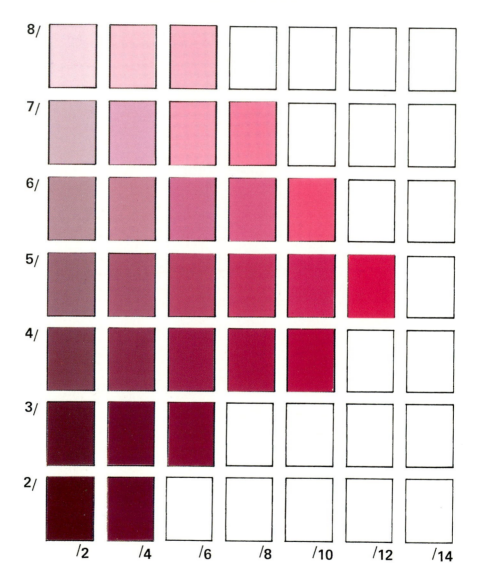

ANNOTATED BIBLIOGRAPHY

Albers, Josef, **Interactions of Colors.** Yale University Press, New Haven and London, 1963. The 1963 edition contains the best explanation of the **color theory of Albers.** The book has seven color plates from the original book and a full outline of color exercises which deal with color interrelationships.

Bailey, Adrian, and Holloway, Adrian, **The Book of Color Photography.** Alfred A. Knopf, New York, 1979. This book contains a good explanation and diagrams of the technical processes involved in both negative and reversal **color photography.** There are also many fine color photographs throughout the book.

Birren, Faber, **Color for Interiors, Historical and Modern.** The Whitney Library of Design, New York, 1963. This book contains a complete discussion of the **history of interior coloration** from Egyptian times to early 1960. There are many photographic examples of interiors and actual color chips which show the colors used in each decorative period.

Birren, Faber, **Color Psychology and Color Therapy.** University Books, New Hyde Park, New York, 1961. This is the decisive book on **functional color,** by a prominent theorist on functional color. The book explains the history of universal associations and also gives very specific directions for industrial coloration in factories, schools, hospitals, and homes.

Birren, Faber, **History of Color in Painting.** Reinhold Publishing Co., New York, 1965. An interesting discussion of the **history of color in painting,** the book gives examples of actual palettes of artists from Egyptian times to the twentieth century.

Chevreul, M. E., **The Principles of Harmony and Contrast of Colours.** Bell and Daldy, London, 1870. This book contains Chevreul's complete outline of his theory of **simultaneous contrast.** The theory is explained at great length, with many examples of use. The book is difficult to read because of the style of writing.

Craig, James, **Production for the Graphic Designer.** Watson-Guptill Publications, New York, 1974. The book contains a good explanation of the

three- and four-color **printing processes,** plus other, simpler color printing processes.

Encyclopaedia Britannica Editors, **How Things Work: Aerosols to Zippers.** Bantam Books, Inc., New York, 1979. This book contains a good explanation and diagrams of how **color television** works, from the studio cameras to the mechanics of the television set.

Fabri, Ralph, **Color: a Complete Guide for Artists.** Watson-Guptill Publications, New York, 1968. This book contains a good discussion of color agents and the **chemical characteristics** of the agents.

Favre, Jean-Paul, **Color Sells Your Package.** ABC Verlag, Zurich, 1969. The book contains the most data on the **universal color associations,** with special focus on the use of color in package design. The book is written in three languages: English, French, and German.

Graves, Maitland, **Color Fundamentals.** McGraw-Hill Book Co., New York, 1952. The book contains a good explanation of the full **Munsell System,** with excellent charts and diagrams of all facets of the system.

Itten, Johannes, **The Art of Color.** Reinhold Publishing Corp., New York, 1961. This book explains all the **color effects** and gives examples of each in student exercises and beautifully selected master paintings.

Jacobsen, Egbert, **Basic Color.** Paul Theobald and Co., Chicago, 1948. A basic color book which contains a complete explanation of the **Ostwald color system,** which is a similar system to the Munsell color system.

Judd, Deane B., and Wyszecki, Gunter, **Color in Business, Science and Industry.** John Wiley & Sons, Inc., New York, 1952. The book contains a complete discussion and diagrams of all the **scientific aspects of color** from wavelength theory to color measurement equipment, plus the results of psychological surveys. Although it was written for the nonprofessional, the book is most useful for specific references rather than general reading.

Kandinsky, Wassily, **Concerning the Spiritual in Art.** Wittenborn Art Books, Inc. New York, 1947. One of the most important books in the world of art, this book contains a complete explanation by Kandinsky of his color theory. The book includes the concepts of **color synesthesia** and personal color associations.

Kepes, Gyorgy, **Language of Vision.** Paul Theobald and Co., Chicago, 1944. A book on all facets of basic design, with an excellent chapter on the **history of color usage.**

Klee, Paul, **The Thinking Eye.** Wittenborn Art Books, Inc., New York, 1961. A complete explanation of the **color theories of Paul Klee,** this book

includes his theory of the balance of color in motion. Klee's writing is difficult to follow, but his ideas give new insights into the basic color effects.

Munsell, Albert H., **A Color Notation.** The Munsell Color Co., Baltimore, 1926. This small book comes with the **Munsell color charts** from the Munsell Color Company. The book contains brief, hard-to-read explanations by Munsell of the system and the uses of the system. The book does not serve as a complete reference to the system.

Taylor, F. A., **Colour Technology.** Oxford University Press, London, 1962. This book contains a complete and simple discussion of the physical and **chemical aspects** of some color agents.

ACKNOWLEDGMENTS

We are grateful to the Munsell Corporation, 2441 North Calvert Street, Baltimore, Maryland 21218, for permission to reproduce components of the Munsell Color System.

We wish to thank the individual artists whose works are reproduced in the manual.

We wish to thank the Nelson Gallery of Art, Atkins Museum, Kansas City, Missouri, for permission to reproduce the following works of art: Otagawa Kuniyoshi, *Famous Views of the Eastern Capital;* Reginald Marsh, *1120 South Street;* majolica plate; Francisco de Zurbarán, *The Entombment of St. Catherine;* Circle of George de la Tour, *St. Sebastian Nursed by St. Irene;* Paul Cézanne, *La Montagne St. Victoire;* Wassily Kandinsky, *Rosa Mit Gran;* and Jacob Lawrence, *House Chores.*

We wish to thank the Kansas City Art Institute for permission to reproduce the following works of art: Douglas Jasso, *Mexican Girl as Cat Women;* and Joanne Nettzle, *Color Exercise.*